30 minute ART

Pastels

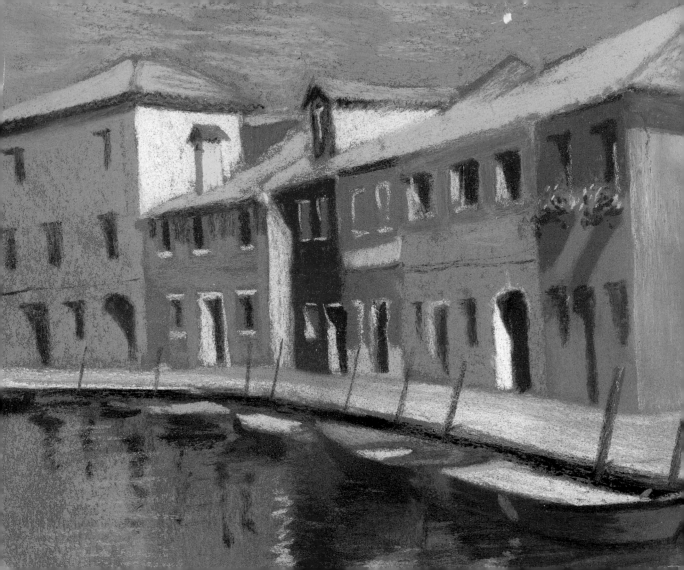

30 minute ART

Pastels

Margaret Evans

Collins

An Imprint of HarperCollins*Publishers*

First published in 2008 by
Collins, an imprint of
HarperCollins*Publishers*
77-85 Fulham Palace Road
Hammersmith, London W6 8JB, UK

www.collins.co.uk

Collins is a registered trademark of HarperCollins Publishers Limited.

FIRST U.S EDITION published in 2008.

HarperCollins books may be purchased for educational, business, or sales
promotional use. For information in the United States, please
write to: Special Markets Department, HarperCollins Publishers,
10 East 53rd St., New York, NY 10022.

www.harpercollins.com

The name of the "Smithsonian," "Smithsonian Institution," and the sunburst
log are registered trademarks of the Smithsonian Institution.

Smithsonian consultant: Stephanie Halpern

Library of Congress Cataloging-in-Publication Data

Evans, Margaret.
 Pastels / Margaret Evans. -- 1st ed.
 p. cm. -- (30-minute art)
 Includes index.
 ISBN 978-0-06-149185-6
 1. Pastel drawing--Technique. I. Title.
 NC880.E93 2008
 741.2'4--dc22
 2007043287

Color reproduction by Colourscan, Singapore
Printed and bound by Printing Express, Hong Kong

12 11 10 09 08
8 7 6 5 4 3 2 1

Dedication

I dedicate this book to my long-suffering and lovely husband Malcolm, who
always has faith in my achievements and helps me reach my goals, and to
Robert Wade for giving me encouragement, inspiration, and advice. Everyone
needs a guru to aspire to!

Acknowledgements

My thanks to all my loyal students from far and near, who have stuck by me,
travel great distances to be taught by me, and offer continuous support
and friendship. My thanks also go to Caroline Churton at HarperCollins for
choosing me as author and for all her encouragement, help, and advice
throughout, and to Diana Vowles, for her patience and skill in making my
text understandable to all.

Page 2: **Burano Houses,** 8 10 in. (20 25 cm.)

CONTENTS

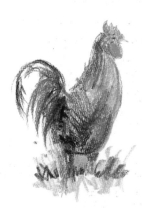

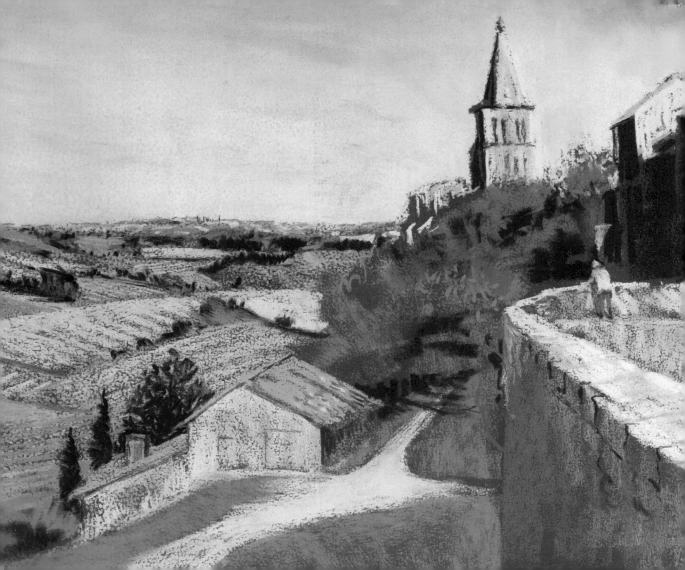

INTRODUCTION

Using pastels is the most versatile and direct way to paint, because it is "hands-on" and creates immediate results. Never has there been a better medium for adapting to 30-minute painting, especially when it comes to helping the amateur artist not only to gain confidence in achieving results quickly but also to gain confidence in painting outdoors, especially in uncertain weather!

With pastels, there is no need to set up water jars, brushes, and palettes—it's as easy as using pencil on paper and a lot more fun. Their dry form makes them convenient to transport; however, if you want to, you can add water and your pastels will turn into pure paint.

◀ **St Felix**
13½ × 18½ in.
(34 × 47 cm.)
Thirty minutes gave me just enough time to block in the golden fields and hazy blue distance on light brown paper.

Advantages of pastels

Pastels offer a variety of ways to paint.
They can be soft and subtle, like the
name suggests, or they can be strong and
vibrant, which is often a surprise to the
uninitiated. They come in all types of
shapes and sizes, from fine pastel pencils
to thick chunks of pure pigment, and the
provide the chance to use quick sketching
techniques as well as fully fledged
painting skills. Most commonly used as
a dry medium, they can also be wetted to
create imaginative textures and solid
color, and they are very compatible with
other media.

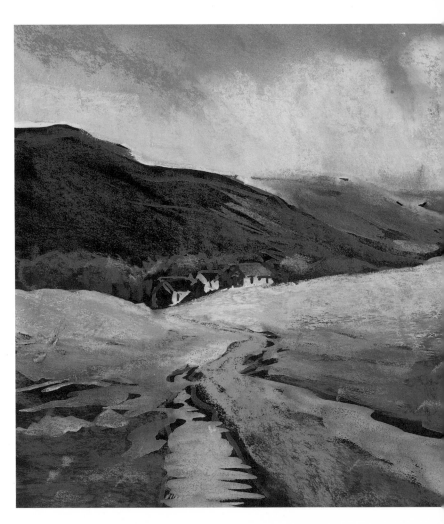

▶ **Highland
Pathway**
9 × 9 in. (23 × 23 cm.)
Here I applied strong
blocks of pastel
colors thickly to a
black paper to create
dynamic contrasts
and atmospheric
tonal variations.

The 30-minute challenge

In 30 minutes, you need to select the subject, plan the strategy, choose the angle, and get it all down quickly! Outdoors, you may be battling with unpredictable weather, and, indoors, grabbing half an hour to do some quick painting may be tricky when there are many tasks you feel you should be doing. The best plan of attack is to be prepared and to keep everything simple.

Look at the subject and ask yourself what it is that attracts you and makes you want to paint it. This is the essence of your painting. Remembering this throughout your allotted time will help you to keep to the important point and not become distracted by inessentials.

The aim of this book

In this book, I have set out to encourage everyone to do something creative in 30 minutes. The essentials are to simplify the subject and not try to duplicate it exactly—look for the big shapes and the little shapes will follow. Remember that you are not attempting to reproduce a photographic reality but to communicate your vision of the subject to the viewer.

Anyone who has ever wanted to be an artist but thinks that he or she doesn't have the time will be amazed at what can be achieved in just half an hour. A complete and complicated work may not be possible, but you will discover from *30-Minute Pastels* that satisfying and exciting paintings certainly are.

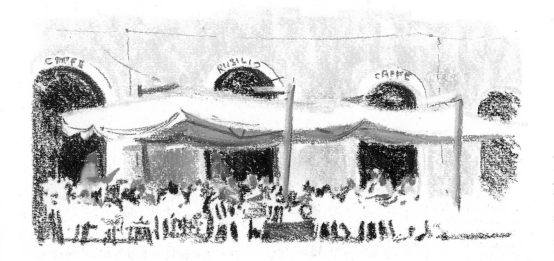

◀ **People at Caffe Rusilio**
4½ × 10 in. (11 × 25 cm.)
A quick sweep of color around the umbrellas gives the setting for diners, leaving the mass shape of figures and umbrellas white.

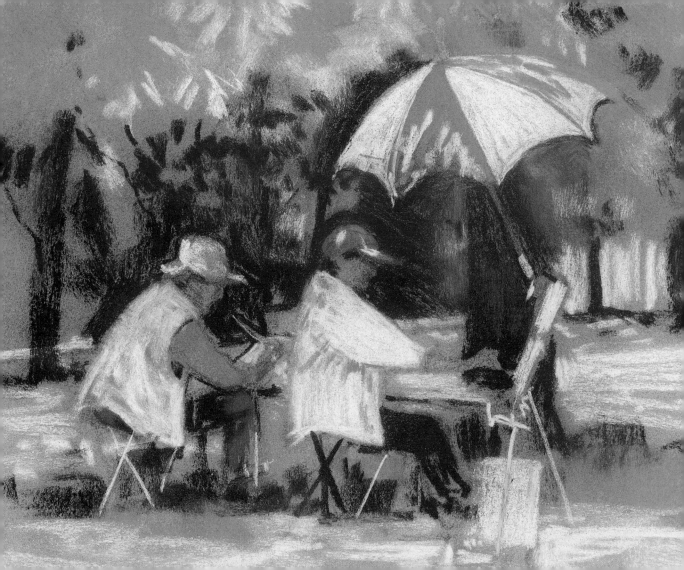

ESSENTIAL EQUIPMENT

Good equipment will help you to get good results and will also make the job easier, but there is no point in setting yourself up with so much equipment that you don't know where to start. That takes up valuable time, and the less decision making you have to do, the more time you have for concentrating on the job—which is painting!

Always think carefully about what you really need. When you come home from a painting session outdoors, always put the things you actually used to one side and what you didn't use to the other— you will be shocked at what you have just hauled around for nothing, and you will be more selective next time.

◀ **Artists at Work**
10 × 12 in. (25 × 30 cm.)
Observing and sketching in the basic outlines of these artists took me only a few minutes, and the rest of the time was spent building up the scene around them.

Pastels

Whether they are soft or hard, pastels are a dry medium. The only exception is oil pastel, which is oil-based and, therefore, feels greasier. It can be diluted with only turpentine.

Soft, hard, and pastel pencils are all compatible with each other and have their own advantages that complement the others.

Soft pastels

The softer brands of pastel, such as Sennelier and Daler-Rowney, have a high percentage of pure pigment held together by binders and can feel crumbly or creamy in texture. They are ideal for solid color applications in painting techniques and for filling in large areas quickly.

Hard pastels

Harder brands, such as Conté Carres or Prismacolor NuPastel, have less pigment, with fillers, such as clay or kaolin, added and binders to hold them together. Because they provide a finer point, they are ideal for sketching and drawing detail.

Pastel pencils

The pastel content inside these pencils tends to be of a harder consistency, otherwise they would break too easily. They are ideal for sketching without being messy, easy to carry, and excellent for detail work. They are best sharpened with a craft knife to expose the pastel core, then used on their side to work into a point.

| QUICK TIP

Choose a pastel type that suits you—some people prefer soft, crumbly ones, but pencils and hard sticks are neater and tidier to use.

◄ **Pastel types**
Pastels range from the soft, creamy varieties to harder, thinner sticks and pastel pencils.

◀ Soft pastels
Soft pastels need very little pressure to produce a solid block of color but are more difficult to control for thinner marks and are more likely to smudge.

▲ Hard pastels
Hard pastels keep their shape, can still block color solidly, but also produce thinner line work for finer detail and quick sketching.

▲ Pastel pencils
Pastel pencils are ideal for sketching and detail work, as well as blocking in small areas of color.

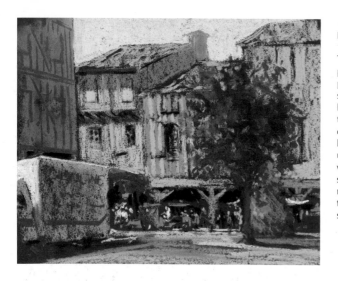

◀ **Market Day, Mirepoix**
10 × 12 in. (25 × 30 cm.)
This example of pastel on a dark blue paper shows the strong effects created by using bright colors thickly to cover the dark base and create light areas and by using them thinly where darker, shadowy tones are needed, allowing the paper to show through.

Surfaces

There are many types of ideal surfaces for pastel, including papers and boards, but all must offer a reasonable "tooth" in order for the pastel to grip well, which helps to avoid smudging. From slight weaves to abrasive sandpapers, the surface plays an important role in pastel painting and has to suit the quantity of pastel being applied—a thick application of soft pastels needs an abrasive surface to grip the medium well, whereas a lighter weave paper is sufficient for sketching with hard pastels or pencils.

▶ **Pastel papers**
One of the most exciting elements of pastel painting is the wide variety of paper colors and textures that is available.

Other equipment

It would be easy to load yourself down with all the best equipment, including an easel, stool, parasol, and table, as well as the full range of top-quality pastels, but that would take about 30 minutes to set up! I have a telescopic easel that leaps into position quickly, with a shelf to hold my tray of chosen pastels, hard and soft, and a board with a folder attached that also holds my papers and finished works in place. I leave the rest of my equipment at the studio for longer painting sessions.

▶ **Equipment**
Other items you might find useful include fixative, a blending stump, and masking tape for holding down your paper. To wet the pastels for painterly effects, you will also need brushes and a palette.

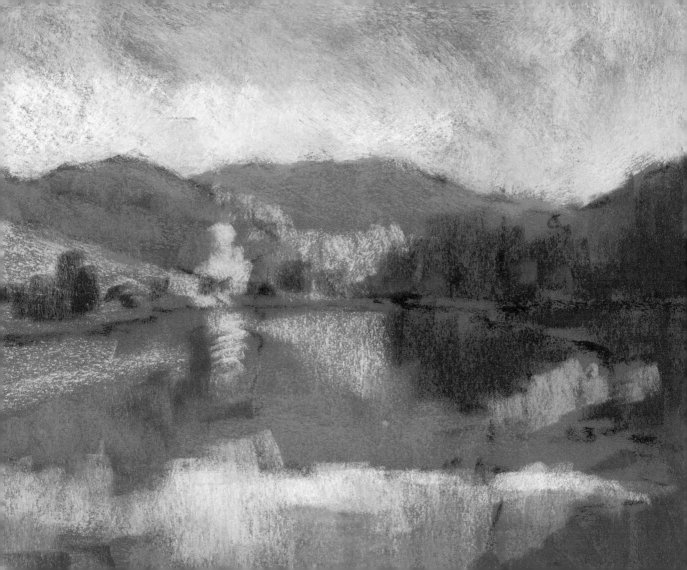

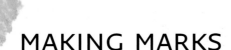

MAKING MARKS

Pastel is tactile and direct, and, therefore, time-saving. Every mark made means something, whether it is a thin line or a strong block of color, which makes it an ideal medium for 30-minute sketching and painting.

Learning the difference between linear and painterly marks along with blocking, layering, and glazing techniques, will teach you how to control the amount of pastel you place in each area of the painting. It will also help you to discover how to cover the paper color or allow it to show through, depending on the pressure of the mark you choose to make.

◀ **Loch and Trees**
12 × 19 in. (30 × 48 cm.)
Sometimes drawing is not necessary; simple bold blocks of color, varying the direction of the strokes as have been done here, can create a quick impression of a scene.

Linear marks

By using the end of the pastel stick, you can make single lines for drawing outline shapes or repeated side strokes to build up a body of color, either parallel to each other or crosshatched to create color mixing and texture.

Lines

To create a single drawing line for outlining and positioning the subject on the page, hold the stick like a pencil and use the end. Vary the pressure to create thin or thick lines and you will discover how crumbly or hard your pastel brand is. You can sharpen hard pastels if you want a pointed edge and pastel pencils are ideal for this; use them slightly on their side to avoid continually blunting the point as you work.

◀ **Linear marks**
Varying the pressure will give you thicker or thinner marks.

▶ **Outlines of Florence**
Using pencils or hard pastels, you can draw simple outline shapes to set out composition ideas then fill them in later with blocks of color.

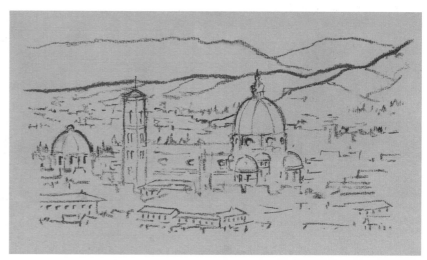

Side strokes

By holding the stick at a lower angle to the paper and repeating the mark more closely, you can build up a mass of color, which fills in areas quickly. The pressure that you use will determine a strong block of color or a light shade that still allows the paper color to show through.

Crosshatching

Using the stick as for side strokes, make marks by building up strokes in opposite directions, either using the same color to create density or varying them to mix colors. To make additional color mixes, add more layers on top, each layer in a different direction from the last.

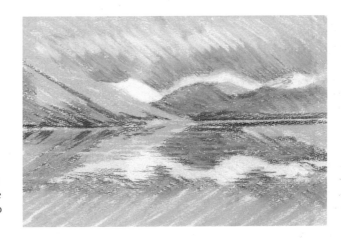

◄ **Highland Loch**
6½ × 11 in. (17 × 28 cm.)
After sketching in the scene, I quickly placed the colors and shapes with side strokes and cross-hatching, building up directional strokes to provide atmosphere.

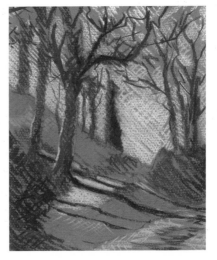

▲ **Pathway**
8 × 10 in (20 × 25 cm.)
Using pencils or hard pastel sticks, color can be built up by crosshatching. This creates a solid mass of color and helps the eye to "mix" colors applied on top of each other.

▲ **Side strokes**
Holding the pastel at an angle, repeat lines to build color.

▲ **Crosshatching**
Making opposite side strokes allows you to mix colors.

Painterly marks

By breaking a pastel stick in half and holding the stick on its side, you can produce a block of color in a similar way to using a flat brush in painting. These painterly marks are ideal for blocking in larger areas of a painting, and they speed up the process of covering paper as well as build up strong color patterns.

Blocking
Holding the stick on its side, put the full width of the pastel on the paper to create a solid mark of color for filling in or showing strong color.

Glazing
Holding the pastel lightly on its side, drag it over previous layers. This shows the color underneath and you can build layers up into glazes, similar to washes in oils or watercolors.

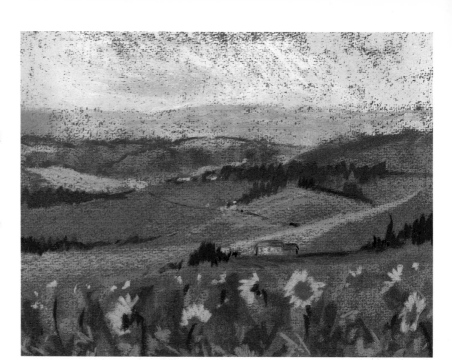

▶ **Blocking**
Blocking in color with the side of the pastel stick is the quickest way to cover a large area and capture the essence of the scene.

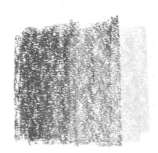

▶ **Glazing**
Glazing creates exciting color mixes when one color is layered on top of another, and it is a useful technique for creating misty, atmospheric effects.

▲ **Sunflowers**
7½ × 10 in. (19 × 25 cm.)
Blocks of colors create an immediate impression of this scene. Glazing colors over each other in the fields gives a feel of the varying hues that occur as the crops move in the breeze.

▶ Stippling

Broken dots of pigment allow the paper color to intersperse with the pastel colors and give a different color visually. Adding additional colors allows the eye to mix them visually.

▶ Broken color

On textured papers, broken color is useful for creating additional textured areas. Varying the size of the strokes will create movement and interest.

Stippling

Stippling pigment on with the end of the stick builds up a dotted effect, giving a vibrant and exciting appearance to the picture; you can place different colors side by side to create strong, colorful textures. You can also achieve a sense of recession by varying the size of the dots, reducing them as they go into the background.

Broken color

Broken strokes or blocks of color can be used for vibrant shimmering effects, creating a texture and liveliness that can sometimes be lost in pastels when an area is blended. Broken color is a particularly successful technique on rough papers, where the pattern of the paper texture adds to the vibrancy of the effect.

▶ Tuscan Doorway

7½ × 9½ in. (19 × 24 cm.)
For old buildings with textured and crumbling walls, stippling and broken color are ideal for creating a busy area. They work especially well against smooth blended areas to create a contrast of textures, adding interest to a painting.

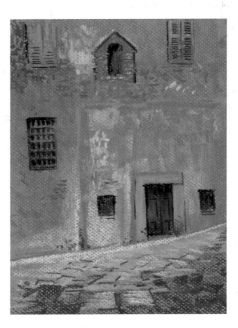

◄ **Layering**
By layering colors on top of each other, you can create mixes and new colors. The same color layered on top of itself will create a stronger, more solid version, covering the paper texture.

▼ **Stone Wall**
5½ × 8 in. (14 × 20 cm.)
The bottom layers of color become smoother as the top layers push the pastel into the paper, and texture is created on top to capture the many facets of stones and boulders. This technique is ideal for foregrounds.

| **QUICK TIP**

Remember that layering is basically color mixing that takes place on the paper instead of on a palette, creating a dynamic and expressive result.

Layering

Layering is best used for mixing colors, because one color on top of another can blend to create subtle and varying results, especially on brickwork, stonework, and so on; you can layer color on color until you achieve what you are looking for. This process of building up layers of pastel creates a thick and thin balance throughout the painting. Where you want the paper color and texture to be part of the finished appearance, apply the layers of pastel lightly; if you want a smoother finish, apply solid layers of color.

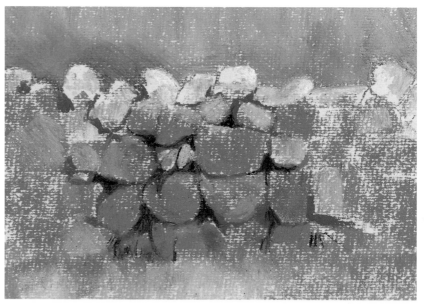

Blending

Blending is a method of rubbing in the pastel to create smoother effects—but it is one of the most overused and abused techniques, and it can lead to dull, overworked paintings. In a 30-minute pastel, keep blending to a minimum.

You can achieve a fresh, painterly approach by applying the pastel with other techniques, then finishing with a light touch of blending to smooth out a few areas, such as skies, to give the picture a rough-and-smooth balance. Blending is mostly done by rubbing with fingers, but you can also use tissue, paper blending stumps, or rubber blenders.

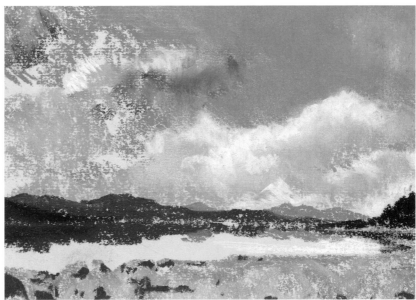

▲ **Scottish Sky**
6 × 9 in. (15 × 23 cm.) Blending for basic sky colors is effective to smooth the area before adding clouds. This is also particularly useful to contrast a smooth sky with a textured subject.

◄ **Blending**
Where two or more colors are mixed on top of each other, you can blend them to create a solid color, covering the paper and creating softer edges.

QUICK TIP

Blending is often better done back at the studio after some thought instead of spending valuable time on it outdoors and perhaps overusing it.

Adding water

Adding water to pastel gives it a whole new look, because the dry pigment turns into paint. You can also dilute pastel with turpentine to create the effect of a thin oil painting. This painterly appearance gives more strength to the argument that pastel is a serious painting medium as well as a sketching tool.

There are three ways of using water with pastel. Applying a damp brush with excess water sponged out to pastel creates solid color as strong as oil or acrylic. Using a wet brush has the opposite effect, diluting the color and creating wash effects similar to watercolor. You can also apply the pastel to dampened paper, which enriches the color.

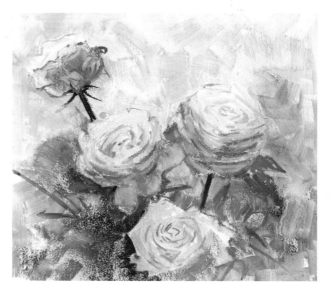

◀ **Cream Roses**
8½ × 10½ in. (22 × 27 cm.)
For a watercolor finish, the technique of adding water to pastel is ideal. Here, I used it for creating soft glazes of color, then for intensifying the colors on the roses and solidifying the foliage shapes.

▶ **Damp brush**
Wetting the pastel with a damp brush intensifies the color and makes it appear more solid. This is ideal for areas where the paper color needs to be covered.

▶ **Wet brush**
Wetting the area of pastel with a brush loaded with plenty of water dilutes the pigment. This makes it a useful way of spreading the color over larger areas and also for laying in base colors for dry pastel to be added on top.

▶ **Damp paper**
Another way to intensify the richness of pastel color is to apply dry pastel to a dampened area of paper. This is ideal for flower painting, where intense color is needed without any background color showing through.

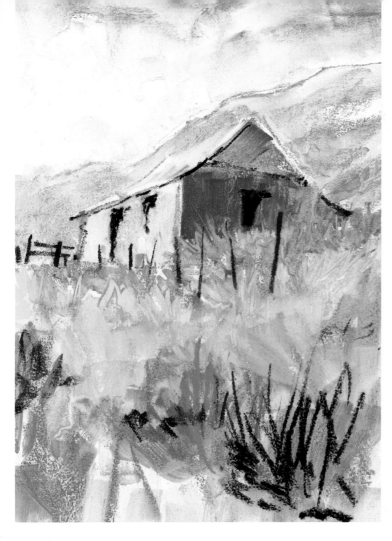

◄ Trossachs Barn

9 × 23 in. (23 × 30 cm.)
I blocked in the colors on white paper, then wetted the pastel to spread the color and cover the white. It created a fluid watercolor appearance and helped to hold the pastel in place, effectively turning it into pure paint.

QUICK OVERVIEW

☐ Linear marks are used for drawing outline shapes and building up color.

☐ Painterly marks are used for blocking in larger areas.

☐ You can mix colors in pastels by putting layers of different colors on top of each other.

☐ Blending creates smoother effects.

☐ Pastel is constituted of pure pigment and, as such, can be wetted with either water or turpentine to turn it into paint.

Exploring different textures

For this first project, experiment with creating textures. Try different varieties of pastels on a range of surfaces and see how diluting the pigments gives you further options to explore.

Dry applications for texture
Using different types of pastel, make dry applications on various paper textures. Rough papers will provide a broken effect, leaving the paper color showing through, while smoother papers with less "tooth" will provide a more solid color.

Wet techniques for diluted color
Experiment with different types of pastel to see which ones dissolve better when water is added. To dilute the color, use a wet brush; this will also be ideal for washes of smooth color, similar to watercolor washes. Some pastels will melt easily into the water and others will resist, creating a different effect again.

◀ **Diluted color**
Adding water with a wet brush dilutes the color so that it spreads into a wash, making it suitable for smooth areas.

▶ **Dry pastel**
Dry pastel applied to white paper will always show up the texture of the surface unless it is blended to smooth it down.

Damp techniques for solid color
Applying a damp brush instead of a wet one to pastel will create glorious rich, vibrant color that will solidify to a smooth block, covering any paper color and texture underneath. When you try this,

▲ **Solid color**
Applying a damp brush over dry pastel creates solid color ideal for strong subjects and pure color for flowers.

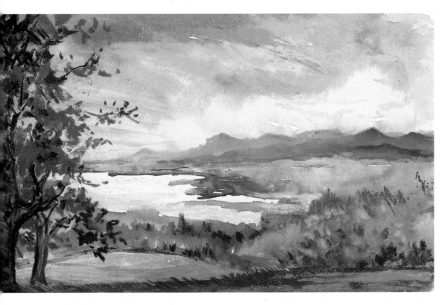

notice how different the result is from using a wet brush, widening your range of possibilities.

Right technique, right subject

Select a few subjects and decide which techniques will most suit each area within them. Dry blocking in and a little blending is ideal for cloudy skies, whereas diluted pastel is good for washing in large areas of landscape. Dry pastel on top of wet washes is also useful for creating texture.

▲ **Hudson River, New York**
8 × 13 in. (20 × 33 cm.)
I put down random colors to suggest a landscape, then added water with a large flat brush to create a base. I applied dry pastel on top in order to pull the composition together and add some texture.

▲ **Old Doorway**
8 × 10 in. (20 × 25 cm.)
I applied light neutral gray pastel to cream paper, then washed over it. While it was still damp, I dragged new colors over the walls to create an old "distressed" effect. Once the previous colors had dried, I built up dry pastel on top.

TONAL VALUES

Capturing the tonal values—the contrasts of light and dark—is the backbone of painting; without them, a painting is flat. The artist starts with a two-dimensional sheet of paper and has to try to create the third dimension, which is done by using tone to show form. By establishing tone quickly, the 30-minute pastel will fall into place, even if the accuracy of color comes later, through memory, photographic backup, or pure imagination.

Squinting at the subject with half-closed eyes will help you to block out the less important halftones, and the stronger contrasts of light and dark will emerge without detail to distract you.

◀ **Glenelg, Scotland**
9 × 12 in. (23 × 30 cm.)
Subtle tonal variations create an atmospheric mood, with a limited use of colors creating a low-key effect.

10-minute tonal studies

On white paper, you can work with simplified tonal values using just three tones—light, medium and dark. The light is the white paper, gray is mid-tone, and black is dark. Imagine this as being on a scale of 1–100 percent, from white to black.

When you are choosing a colored paper on which to work with pastel, it is important to assess straight away if the paper is light, medium, or dark in tone. If it is a mid-tone, you can use white for highlights and black for darks; if the paper is a dark tone, such as black, mid-tones and highlights can be added with gray and white.

Color and tone
You do not have to use black for dark tones and white for light. Even if the paper is a mid-tone value, you can identify the three tones with cream and brown pencils, using the paper color as the mid-tone.

When you are selecting your color range for paintings with more than the three basic tones, consider the tonal values of each color you plan to use and make sure they cover the range from light to dark.

▲ The three main tones: white, gray, and black, which represent light, medium, and dark.

QUICK TIP

Shading in with a black pastel as lightly as possible, then applying more pressure until you achieve pure black is a good way of learning about tonal values.

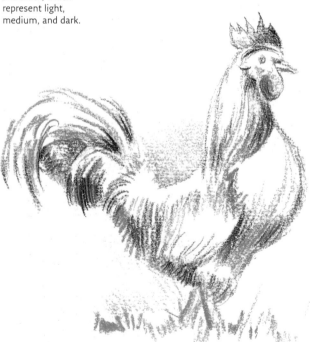

◀ **Hen**
Using one color but varying the tone by increasing or decreasing the pressure with which you apply the pastel will give your subject excellent variety of light and shade.

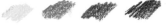

▲ Italian House
5½ × 6½ in. (14 × 17 cm.)
With just four pastel
pencils selected to
cover four tonal
variations, a quick
sketch of a house
gave me enough
information to do an
entire painting later.

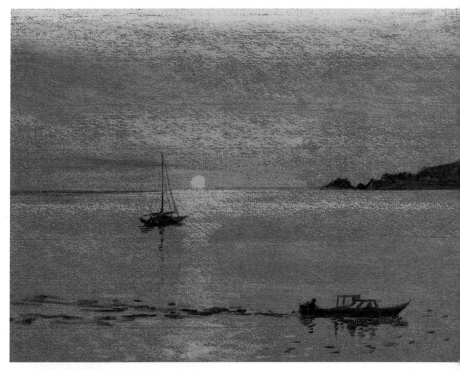

▲ Mexican Sunset
8 × 12 in. (20 × 30 cm.)
A dark gray paper
offered me the
perfect contrast on
which to paint a
vibrant Mexican
sunset quickly,
using just five colors
that span the tonal
range of light,
medium, and dark.

Working in monochrome

The best way to explore as many tonal variations as possible is to try a study using only one color, ideally of a dark tone, such as dark green. By varying the pressure on the paper, it is possible to achieve even five or six varying shades of that color, including the paper tone.

A more challenging study is to see how many tones you can achieve with a color range, such as yellow or red. These are often thought to be "light" colors, but by putting them against each other you will find their tonal values easier to evaluate.

QUICK TIP

Working with one color can save time when you are painting quickly outdoors. You can record the color with a camera to paint it later—or use your imagination.

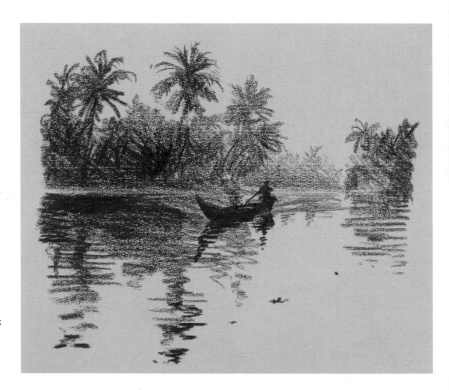

▶ **Indian Canoe**
9 × 10 in. (23 × 25 cm.)
Varying the pressure when applying one color can give plenty of different tonal values, making quick sketching even simpler with less to carry and less to think about!

▼ **Dancer**

8½ × 10 in. (22 × 26 cm.)
Without including
details of her
features, the pose
of this dancer could
be quickly captured
to create the mood
in shades of red.

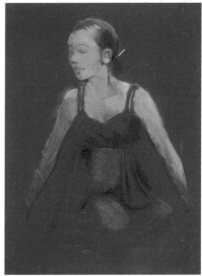

▲ **Yellow Sky**

8 × 12 in. (20 × 30 cm.)
Yellow is thought of
as a light tone but
with different types of
yellow against a dark
background, variations
can create drama and
keep the palette to
a minimum.

Using a limited tonal range

You have learned to think of black and white as a scale of 1–100 percent; now, to create mood and subtlety, try to restrict this range of tones to 30–70 percent. This means creating a softer range, not using anything as dark as black or as light as white. This is a more challenging perception of tonal ranges, but it is ideal for changing the mood of a subject, not only in misty landscapes for atmospheric effect but also for subtlety in portraiture, for example.

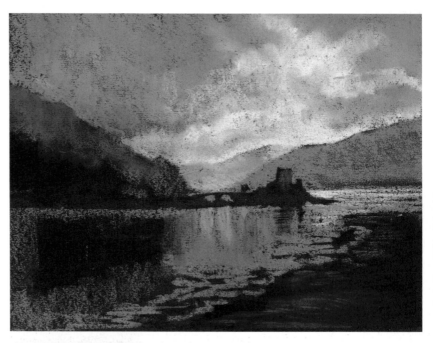

▲ **Eilean Donan Mists**

8 × 11 in. (20 × 28 cm.)
I kept the range of tones close together in this painting to create a soft, moody atmosphere that suited the subject.

▼ **Villefranche-sur-Mer**

13 × 18 in. (33 × 46 cm.)
I quickly captured the strong sunlight on these colorful buildings by contrasting the tonal values on a wide scale.

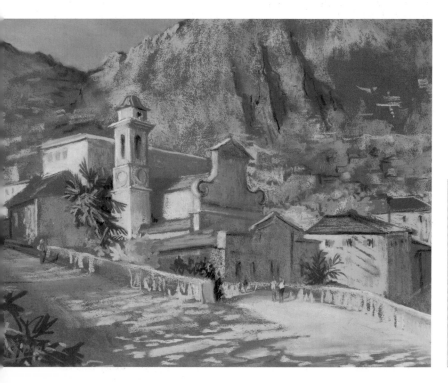

Using a wider tonal range

By extending that range of colors to cover a wider tonal scale, the drama and clarity of a scene can be changed, particularly in strong sunshine. Many paintings lack a sense of strong sunlight, simply because the tonal range is not wide enough. The more contrast, the stronger the sunshine will appear.

QUICK OVERVIEW

☐ At its simplest, your tonal range can consist of just three tones: light, medium, and dark.

☐ Working in monochrome makes quick sketching even simpler.

☐ The tonal range of a picture can be narrow to create moody, atmospheric, low-key paintings or wide to achieve impact and drama.

Sketching tonal values

In even the simplest sketch, exploring the tonal values of your subject will bring it to life. On location, it is important to sketch in your tonal contrasts first because the light will change constantly, affecting them while you work.

MATERIALS USED

Canson white
 sketching paper
Stablio CarbOthello
dark gray pastel pencil
Soft pastels
Burnt sienna
Cream
Deep ocher
French
 ultramarine
Orange
Pale blue
Pinky-gray
Raw umber
Reddish brown
Sea green

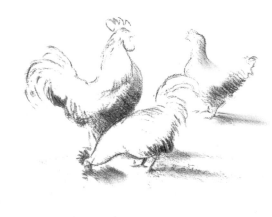

1 With the dark gray pastel pencil, outline the shapes of each chicken, making sure they interact as shown here. Once you have established the basic composition, use the pastel pencil to block in shadows in order to create a strong tonal image and record the direction the light is coming from.

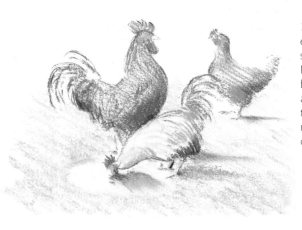

2 Add your colors lightly enough to allow the shadows to show through. Put in a few soft background colors to anchor the chickens to the ground and show the reflection of the foreground chicken in the puddle.

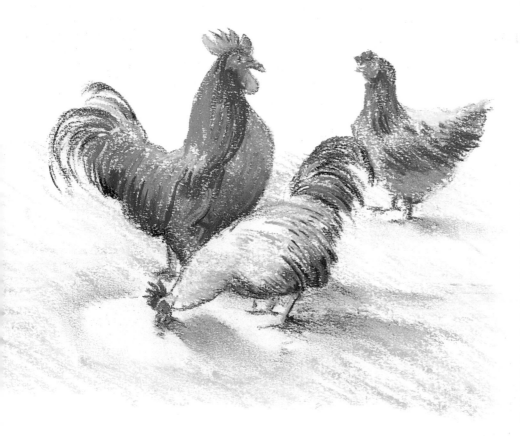

3 Strengthen the colors to create impact, especially on the large chicken, whose rich red-brown colors help to make the softer-colored chicken come forward. The background chicken is basically gold; use hints of this color in the large chicken to link the two, and blend the colors you used in the ground into the feathers of each bird. Strengthen the soft colors in the foreground to make the puddle stand out and darken the reflection.

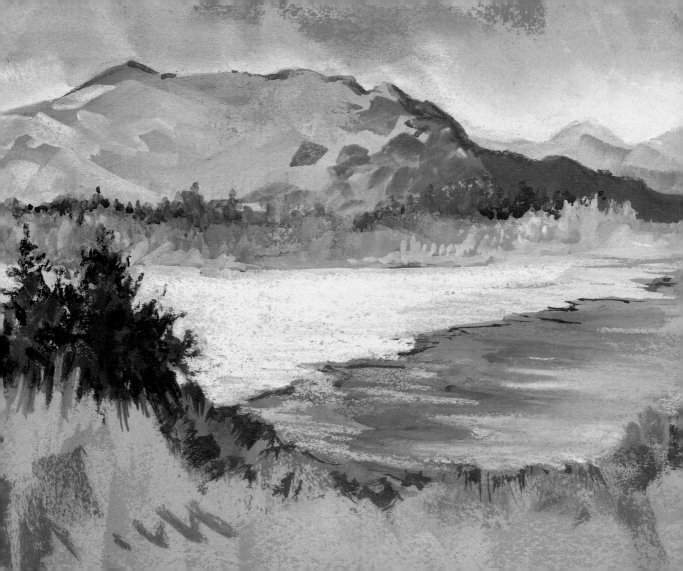

SIMPLIFYING COLORS

When you are working quickly, it is important to see colors in a simplified manner. Instead of looking for an exact match in your pastel collection, it is fastest to record the basic color and then add a few additional colors on top to show what adjustments are needed. Using thick or thin applications of pastel will allow the paper color to play a part in the picture where it is of most use, which also helps to save time and provide impact.

It is better to overstate than understate in painting, and use your imagination—relying on the camera to record the subject often leads to disappointing and understated paintings.

◀ **Californian Landscape**
8 × 14 in. (20 × 35 cm.)
A painting should have "impact colors" that immediately portray the mood and colors of the landscape. Here, the hot red paper blends with the strong golds and yellows to create an impression of a hot country.

A limited palette

Colors fall into three categories: the three primary colors red, blue, and yellow, which cannot be made by mixing other colors together; secondary colors, made by mixing two primary colors together, such as orange and purple; and tertiary colors, which are neutral colors, such as browns and grays, containing all three primary colors, or a primary and secondary color.

A valuable method of working quickly is to simplify your choices of color; a limited palette saves time and encourages you to put down color information simply and boldly. A minimum palette could contain approximately 10 pastels—one each of yellow, red, blue, orange, purple, and green, three neutrals, and white. You can subsequently add your favorite colors to make the choice more personal, helping to develop an individual color scheme or style that will become recognizable as your work.

▶ **Choosing colors**
Using a basic palette will ensure that color mixing can be achieved just as in any other medium. After this, the fun is in supplementing the pastel box with extras.

 Lemon Yellow

 Cadmium Red

 French Ultramarine

 Orange

 Purple

 Green

 Naples Yellow

 Raw Sienna

 Burnt Umber

 Burnt Sienna

 Sky Blue

Blue Gray

Indigo

Dark Green

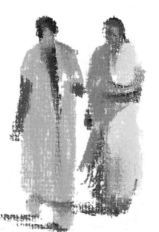

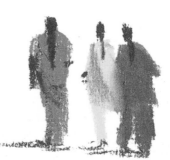

◀ **Indian Girls**
Thin Conté sticks are useful for sketching brightly colored figures for street scenes, such as these Indian girls in their saris.

Color themes

You can use color themes to enhance a scene by limiting yourself to different tones and tints of one main color—for example, a painting done in variations of green. This method of working creates a mood and helps to emphasize tonal qualities. It also saves time when you are making a painting in 30 minutes, particularly if you decide on the color theme in advance.

▼ Green selection
A range of greens is useful in any pastel set. Choose them to cover light, medium, and dark tones.

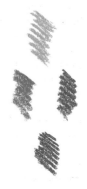

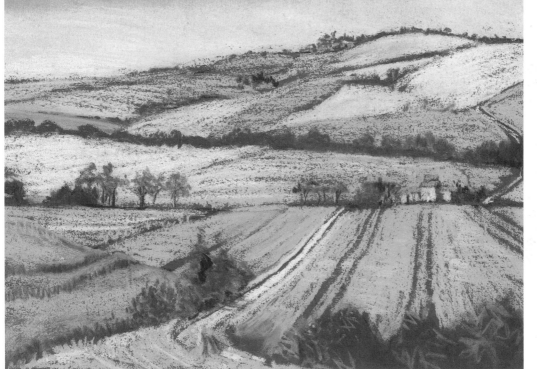

◀ French Landscape
9 × 13 in. (23 × 33 cm.)
This painting is predominantly a green scene with yellow golds. The contrast of the dark eggplant paper offers a relief from the greens and creates a background for shadow areas.

The color wheel

Keeping a mental image of the most basic of color wheels will help you to decide quickly on color. By visualizing the wheel in three segments of the primary colors red, blue, and yellow, you can quickly work out which colors will complement each one because these will be a mix of the other two colors.

For example, if the scene is predominantly reds, varying from rusty brown reds to purplish reds, a green (a mix of blue and yellow) will be complementary to all of them. Although more complex color wheels are useful, this approach keeps choosing colors simple and saves time.

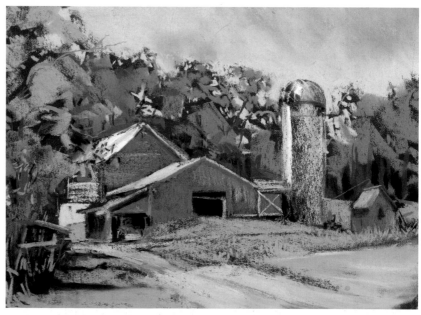

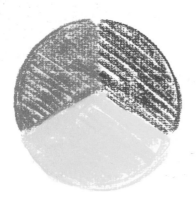

◀ **Three-color wheel**
This simplest of color wheels can be easily imagined or roughly sketched onto the corner of a painting to act as a reminder of the complementaries.

▼ **Complementary colors**

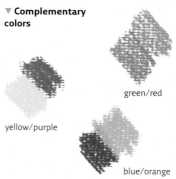

green/red

yellow/purple

blue/orange

▲ **Hudson River Farm, New York**
9 × 13 in. (23 × 33 cm.)
The strong light was best captured by using black paper to help create strong shadows and accentuate the red/green balances of the composition.

Complementary balances

Working with pastels, you also have the option of choosing a paper in a complementary color to the main theme of your painting, or in a color that will emphasize the complementary colors you are applying. Because opposite colors create a strong balance, using them will give you an instant impact for 30-minute works. As soon as the opposite color is added to a colored paper, it seems to vibrate and create an exciting reaction.

▶ **Indian River Scene**
8 × 10 in. (25 × 20 cm.)
The red paper provided the strong red balance against a very green scene, breaking up these greens to create more movement and vibrancy.

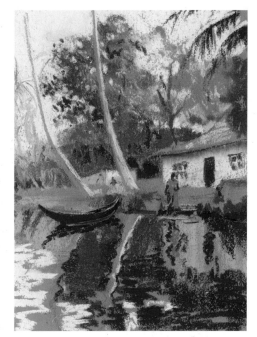

◀ **Spanish Rock House**
9 × 11 in. (23 × 28 cm.)
Hot orange and stark white are the predominant colors in this study, with blue paper providing a complementary balance.

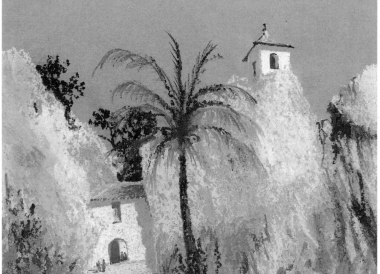

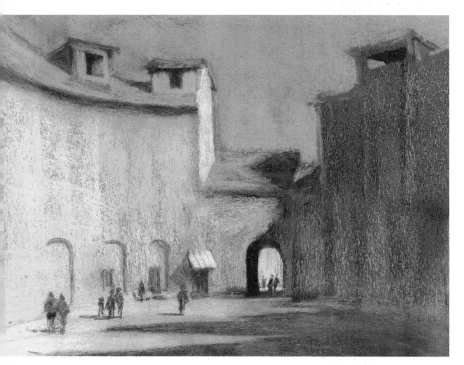

Color temperature

Certain colors are recognized generally as being either warm or cool—for example, red is thought of as a warm color and blue is cool.

However, it is important to realize that within each category there are warmer and cooler versions. For example, French Ultramarine, which is more purple-orientated, is a warm blue, while Phthalo Blue and Prussian Blue are cooler; reds tending toward purple have blue in them, and are, therefore, cooler than reds tending toward orange, which are warmer.

Colored papers

Hot scenes look great on a cool-colored paper, and cool scenes, such as snowy landscapes, are stunning on hot red or orange papers. Once you have found success in balancing these together, it is exciting to try painting hot on hot and cold on cold instead, applying the opposites to shadows in order to create the same balance.

When you are using neutral papers, including white, you will need to build up the painting with balances of warm and cool colors. However, a great time-saver for the 30-minute pastel is to use opposite-colored papers to begin with because they help to create instant impact.

▲ **Lucca, Tuscany**
9 × 12 in. (23 × 30 cm.)
Here the warm ochers and yellows of the buildings are exaggerated by the hot red paper, so I used strong blues to cool down the shadow areas and create a warm/cool balance.

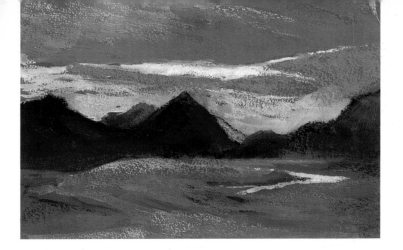

QUICK TIP

Learn to assess the subject quickly as a generally warm or cool one—there will be both warm and cool in all subjects, but a first impression will tell you which to create as the dominant tone in your painting.

▲ **Cuillins from Sligachan, Skye**
10 × 15 in. (25 × 38 cm.)
A cold blustery day on Skye in Scotland would look really chilly on blue paper, but painting on to hot terra-cotta color creates an underlying warmth and added drama that suits the mountains known as the Red Cuillins.

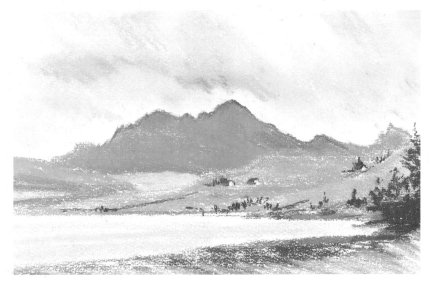

◀ **Cuillins from Carbost, Skye**
6½ × 11 in. (17 × 28 cm.)
I created a different mood by using white paper to depict a similar view of the Cuillins, adding warm and cool balances with pastel instead of relying on the paper color for this.

Combining color and tone

When you are combining color and tone, it is important to have a clear idea of the sensation you want to create with your painting. Impact is important to attract the viewer's attention, but not all subjects are suitable for a dramatic approach—something more subtle and atmospheric may be the answer. The combination of tonal variation and a good balance of color is the secret to success in both low-key and high-key themes.

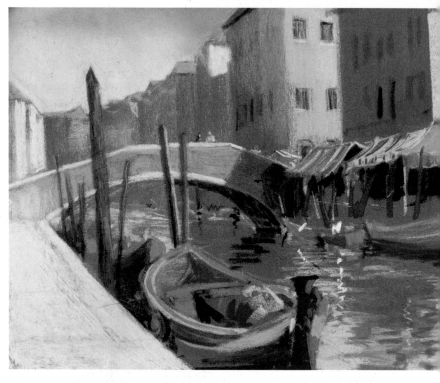

▲ **Yellow and Blue Boats, Venice**
9 × 12 in. (23 × 30 cm.)
The strong Italian sunshine catching the primary colors of the boats in Chioggia, Venice, makes them stand out against the lightly painted background buildings, which melt slightly into the dark brown paper.

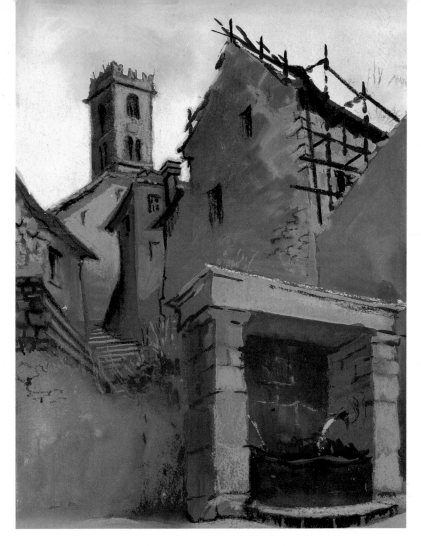

◀ Tuscan Village
9 × 12 in. (23 × 30 cm.)
The day was dark and thundery, and low in tonal variation. Using a terra-cotta paper for underlying warmth, I added washes of gray-blue over the building areas, then gave them more detail with thin, light touches of color. I put in the sky as a stronger contrast against the buildings.

QUICK OVERVIEW

☐ To simplify colors, limit your choices to save time on making decisions and mixing.

☐ Use complementary colors to create balance and impact.

☐ Make sure you include a balance of warm and cool colors.

☐ Take advantage of colored papers to give you complementary and warm or cool colors.

◀ **Warm and cool**
Place a green and a purple and a purplish pink and an orange either side of your blues and reds, respectively, to identify which are warm or cool.

▼ **Emphasizing shapes**
Setting cool colors against warm and light tones against dark makes shapes stand out.

Exploring color and tone

For a 30-minute painting, it is important to save time by limiting your colors. However, make sure that each color works for its keep, not only on its own merits but also in terms of the effect it will have upon the other colors you have chosen.

Color temperature

Take some blues or reds, and lay them in order from cool to warm. For example, since you add blue to red to make purple, a red that goes toward a purplish pink tint will be cooler than a red that goes toward orange, made by adding yellow. In a blue range, the blue that goes toward purple will be warmer than the blue that cools off into green.

This exercise will make you more aware of different effects you can achieve by placing two colors together, and this will help you to save time when you are choosing your palette.

Tonal relationships

Draw a simple hill shape, then put a pale sky blue above it and warm greens on the hill. Try different greens next to the sky blue to see how many different moods can be achieved. Next, draw the same shape, put a strong warm blue sky behind it, and use cooler, lighter greens on the hill. The hill now stands out as a lighter shape against the darker tone, in contrast to the first one.

Draw the same simple hill shape with a blue-gray pastel and fill it in. Next, draw the outline of the hill but fill in the sky instead, leaving the hill as white paper. You can see from trying these exercises that every color also has a tonal depth, which can be used to make shapes stand out.

cool against warm

light against dark

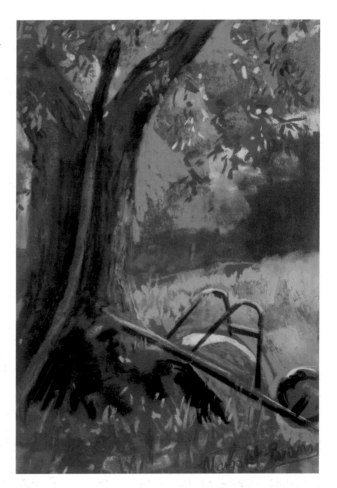

◄ Warm paper
Against this bright red paper, the blue of the hill is very cool.

◄ Cool paper
On cool blue paper, adding a touch of pink to the sky provides some contrasting warmth.

Colored paper

All judgement of colors and tones is dependent upon what they are seen next to, so changing the paper color will also change the tone and color relationship of each pigment you work with. Try the same simple exercise on a red paper, then on a blue paper to see how the concept of warm and cool colors changes. If you find this confusing, remember to keep it simple and be aware of the choice of paper color right at the start of your painting. If it is a hot scene, try a cool blue paper; for a cold scene, choose a warm one.

► Tuscan Wheelbarrow

7 x 10 in. (18 x 25 cm.)
The bright sunlight against the dark tree trunk inspired me to use a dark blue paper and highlight strong contrasts for impact.

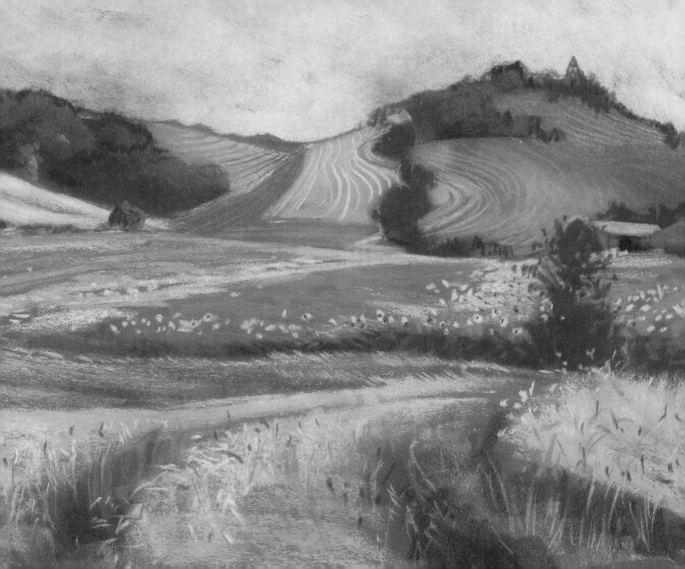

PICTURE BUILDING

It is much too easy to become involved in detailed drawing and run out of time to paint! For a 30-minute painting, you'll find that a plan for time allocation is essential, together with a mental summary of how you will tackle the most vital points, such as composition and light source.

Remember that your intention should be to capture an artist's impression of the subject instead of making a photographic replica. When you have only 30 minutes to spend on the painting, you need to concentrate on what is important and not make any attempt to copy everything slavishly.

◀ **French Fields in June**
13 × 18½ in. (33 × 47 cm.)
The crop fields and sunflowers create a wonderful pattern of textures leading up to the hilltop village in the distance.

Sketching

The sketching stage is a method which, with practice, you will be able to do in five minutes, allowing maximum time for painting. It's a matter of learning to see the big shapes instead of all the details, and letting your line simplify these shapes and join areas together, like taking a line for a walk.

Line

Focus on only the big shapes and divide the page into main areas; for example, land, sky, and foreground. If the subject involves many shapes, such as houses or trees, see them as one large shape instead of individual items, which will allow the drawing to take shape in minutes.

Composition

While you are making the line drawing, be aware of how shapes link up together and balance. Avoid placing your focal points too centrally and drawing shapes that take your eye out of the picture. Imagine that your picture is divided into thirds horizontally and vertically and place your points of interest one-third of the way in from any edge (known as the rule of thirds). Ideally, a good composition should let the viewer's eye meander through the painting, not be led out of the frame or straight to the center.

◀ **Linear sketch**
A rough outline has been sketched in to work out the positions of the main shapes. The skyline of trees and bushes is one large shape.

▶ **Composition sketch**
The pillar added on the right leads the eye from the back of the path, across the left side, and down the opposite pillar.

◀ **Exploring the format**
It is always worth while spending a few minutes playing about with different formats to see if the proportion of the main features is improved.

Proportion

Sketching in the large shapes first helps you to avoid making smaller shapes, such as buildings, people ,and trees, too big and discovering that you have run out of space on your paper. The larger shapes will contain the smaller ones, and, by accommodating them comfortably in the painting, they will make it easier for you to place the small details later.

◀ **Sketching stage**
The basic linear shapes are drawn in with a color that will feature in the painting—in this case, a dark green. The paper is mid-tone warm ocher, which will play a part in the earthy color scheme underlying the greenery.

Blocking

The blocking stage lays the main building blocks of color onto the painting quickly, and should take no more than 10 minutes, which allows 15 minutes for the final stages and details. You can capture sudden changes of light source at this stage, and putting in shadows early will keep the essence of the picture fresh.

Pastel blocks

Breaking pastel sticks to a workable size, such as half or one-third in length, makes it easy for you to apply them by holding the side of the stick and blocking in color. Laying the pastel on with varying pressure will give you thick or thin marks, which can be used to cover the paper color or let it show through respectively, which in turn affects the color and tone.

Pastel layers

The next step is to layer pastel on top of your previous layers, adjusting tonal shading, intensifying color, mixing new colors directly on the paper and building up body on the painting. Some papers will take only a limited amount of layers before the pastel slips and is more difficult to apply, but better papers with abrasive surfaces will grip the pastel and hold many more layers.

◀ **Pastel blocks**
Blocking in with the side of a broken pastel stick is like painting with a flat brush, and creates a painterly stroke that helps to cover the area quickly.

▶ **Pastel layers**
After the initial blocking in of basic colors, additional layers can be added to adjust the color and tone of the mix to suit the subject.

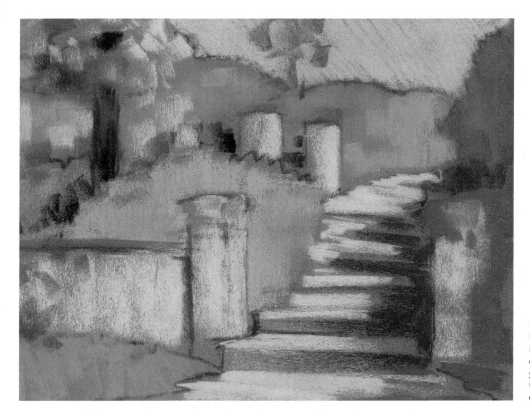

◀ **Blocking-in stage**
Exaggerating the
light and dark tones
initially captures
changing light and
gives impact to
the subject at this
early stage.

Color and tone

Colors at this stage will be approximate.
It is more important to overstate rather
than understate, so apply strong colors—
for example, a pinky-grsy wall can be
quickly blocked in pink and made more
subtle and gray in later stages. Stressing
the tones early helps to allow for the
changes of light that are inevitable
outdoors and even occur with indoor
subjects. Keep the color range limited to
avoid the composition becoming chaotic.

Building

The building stage is fun, because you have 15 minutes left! Working around the painting in a circular method, build up each section with detail at the focal points and layers of extra colors elsewhere. This stage is about "pushing and pulling." Some features of the composition may need to be given more importance and can be pulled forward by detailing or sharpening the tonal values, whereas other areas that are too prominent will need pushing back with glazes of overlaying colors to quieten them.

Blending

At this stage, some areas will need blending to create a smoother finish, either because the paper is textured and rough, or to soften colors that have been mixed together. You can do this with your fingers, but it is important not to carry too much color from one area to another, otherwise everything will become muddy and flat. Blending can also be done by pulling a harder pastel over soft pastels. This makes less of a colur change, and pushes the previous pastel into the paper surface more, creating the smoother effect.

Textural marks

Apart from the texture you will obtain simply by applying pastel to abrasive papers, you can make textural marks by stippling, crosshatching, and applying broken color, all of which can create depth. Colors laid on top of each other, with parts of each color still showing, will add volume and interest to your painting. You can also add texture with final detailed marks made with pencils or a fine dampened brush.

Interesting pictures contain variety, so don't be afraid to leave some areas understated and lacking texture.

▶ **Blending**
After blocking and layering, there will be some areas of color that need blending, perhaps to give a smoother finish or simply to banish the underlying color of the paper.

◀ **Textural marks**
Adding other types of marks, such as stippling and broken color—especially in areas, such as gardens—can add additional depth to the painting.

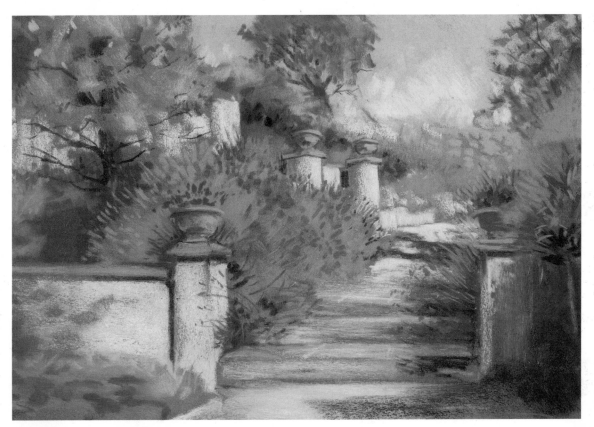

▲ Guiraude Lavender
12½ × 18½ in.
(32 × 47 cm.)
Finally detail is built up in some areas and others are left as suggestions. It is important not to overwork or fiddle with a picture or its freshness will be lost.

Quick studies

Limiting your time on a painting is an excellent way of making sure you take down the important details first and guarantees there is no time mess about with it or fiddle with too much detail. A fresh, sketchy approach is always better than a tired, overworked painting.

Practice this by seeing how much you can get down in 10-minute studies, then limit yourself even more to 5 minutes. By disciplining yourself to work in this small timescale, you will find that your work will automatically become fresher, your speed will pick up, and outdoor painting will not seem so scary. Remember that putting the big shapes in first makes the whole picture appear more quickly; the smaller ones can follow in the time remaining.

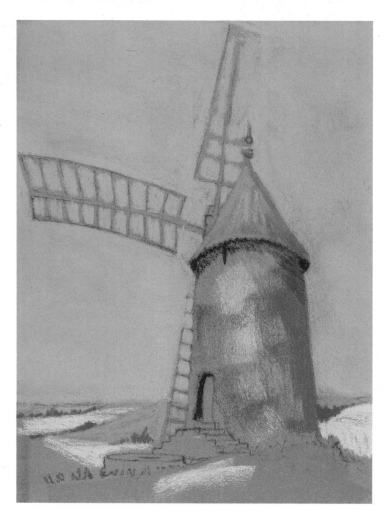

▶ **French Windmill**
9 × 12 in. (23 × 30 cm.) It was important to fit the large shape of the windmill and sails into the page to capture the overall shape of the subject in the composition.

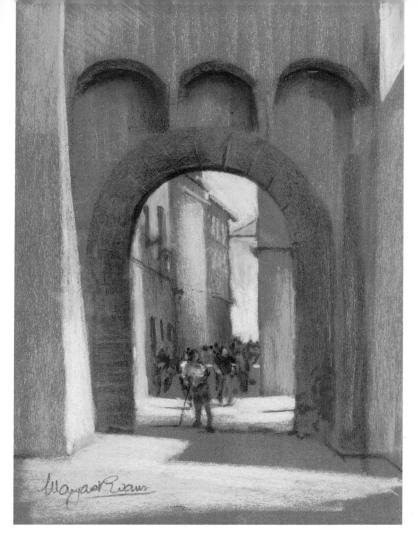

◄ **Pienza Gateway**
9 × 12 in. (23 × 30 cm.)
Looking through a doorway or gate helps to contain the subject. Quickly blocking in the surround of this frame allowed me to spend more time on the subject within.

QUICK OVERVIEW

☐ To begin a picture, take five minutes to sketch in your composition, starting with the large shapes.

☐ Block in the main areas of color, then add intensity and tone by layering on more pigment.

☐ In the final stages, use blending to smooth some areas in contrast to textured ones.

☐ To practice getting down the essentials, try both 10-minute and 5-minutes studies.

Simplifying shapes

Picture building is about seeing your subject in simple blocks and shapes that help the eye to move around the scene. With this ability to simplify, you will be confident to take on any subject no matter how complicated it first appears.

MATERIALS

Sennelier La Carte
 pastel board in Sand
Thin dark green
 Conté crayon
Soft pastels
Bright green
Creamy yellow
Golden brown
Golden orange
Greenish ocher
Indigo
Light green
Pale blue
Pale cream
Purplish gray
Red
Bluish green

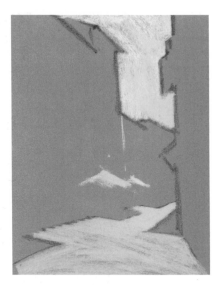

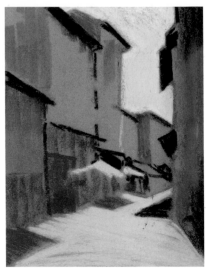

1 Sketch in the outline shape of the buildings with the Conté crayon, emphasizing the angle of the roofs and narrow street. Add strong light tones to the sky and pavement areas to give a sense of sunlight, using warm and cool colors respectively.

2 Put in the strongest shadows and link them together wherever possible to create a balanced composition of darks and lights. Using indigo, place the darkest tones under the roof eaves first, then add the slightly lighter shadows with purplish gray.

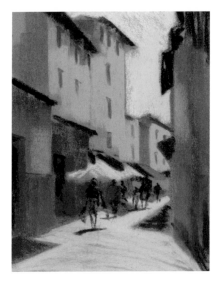

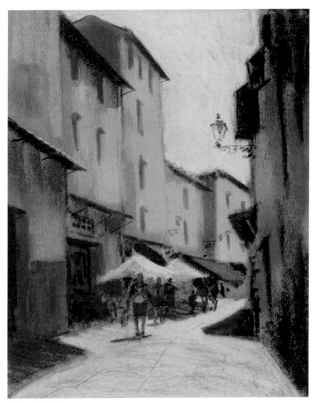

3 Now that the main light and dark tones are positioned, block in the basic colors of the buildings, using greenish ocher with pale cream on top. Lightly blend the colors over some of the shadows. Using indigo, roughly position the windows, doorways, and figures.

◀ **Lucca Shoppers**
10 × 12½ in. (25 × 32 cm.)

4 Strengthen the building colors with a creamy yellow. Suggest a few details of the figures walking on the street—a dot of color will be more effective than trying to draw in exact detail, which would require pencils or thin pastels and take up too much time.

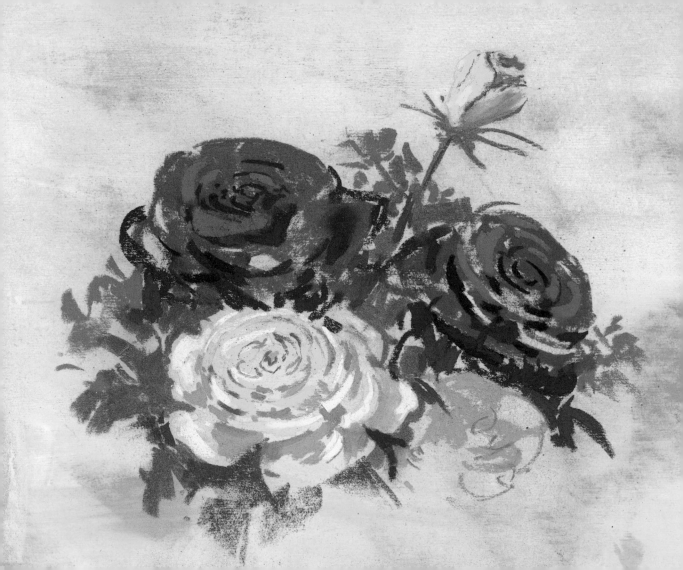

WORKING INDOORS

Working indoors tends to be more comfortable, so time does not seem so much of an issue. However, the discipline of keeping to a 30-minute time limit will act like a tonic to keep your work fresh and expressive—it is all too easy to work away at a painting until it is "finished," not realizing that, in fact, it has been overworked.

Whether you are painting a still life, flowers, or a portrait from life, or working from photographs, the discipline remains the same throughout—keep it simple. This approach encourages you to make sketches and preliminary works instead of facing the pressure of trying to create a finished painting every time.

◀ **Roses in Bloom**
8 × 10 in. (20 × 25 cm.)
I subdued the starkness of white paper by choosing some random pastel colors and washing them over the whole area. Once they were dry, I painted the flowers on top.

Still life

The best way of motivating yourself to paint indoors is to set up a simple still life of a few personal possessions in the corner of a room and observe them from different angles. The great thing about 30-minute pastels is that you can fit your painting inbetween other jobs, and, by leaving your still life subject out on show, you can look at it every time you pass and consider how you will tackle it when you have the time.

Keep your choice of subject simple and be selective—too many objects will clutter and complicate the picture. Try a theme, such as gardening items, children's toys, or a particular color scheme; random objects will not gel together and will make a less interesting impact.

Before launching into a composition of several objects together, it is a good idea to spend five minutes studying single, uncomplicated objects, such as a piece of fruit or a dish. This accustoms your eye to look not only for linear information but tonal values, too.

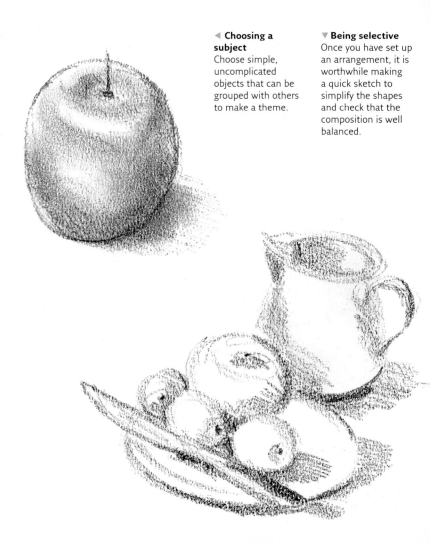

◄ **Choosing a subject**
Choose simple, uncomplicated objects that can be grouped with others to make a theme.

▼ **Being selective**
Once you have set up an arrangement, it is worthwhile making a quick sketch to simplify the shapes and check that the composition is well balanced.

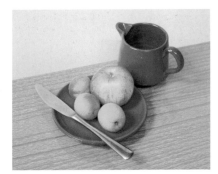

▲ Still life group
This group is lit from one side to produce simple shadows. The high angle of view exaggerates the inside of the pitcher and enhances the ellipses and circles in the composition.

▶ Still Life
7 × 8½ in. (18 × 22 cm.)
The subject is placed on a green background to contrast with its warm oranges and browns and help to unify the picture. The shadows repeat the green background in dark green and highlights of palest green.

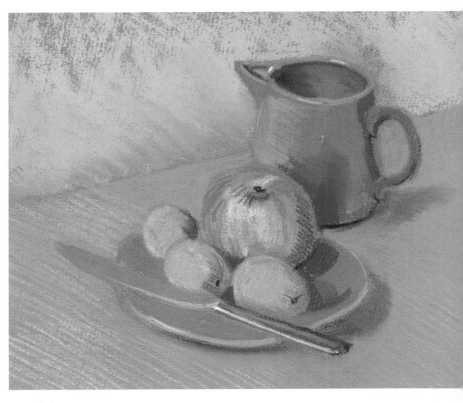

QUICK TIP

Restrict your still life to a limited number of objects and be selective about which part will be the focal point, giving it more detail than the other elements.

Flowers

A study of a single flower is ideal to start with for a 30-minute painting. This allows you to really observe the shape and structure of the flower and create the basic relationship between flower, stem, and leaves. By sketching in each of these elements of the flower and then blocking in the main colors, you will have plenty of time left to work into the flower itself and create the texture and detail.

Grouping flowers

Within a bunch of flowers there should be two or three main "character" flowers that will become the focal points. The remainder should be a supporting background, with much less detail, creating softer vignette backgrounds to the main flowers. If the paper is substantial enough to take water, washes over the background colors is an ideal technique for covering paper quickly and giving a fluid look to the painting.

▲ Foxglove
A foxglove is easily captured by drawing the stem in a single line and leaving some flower heads without detail to create a softer, sketchy effect.

▶ Floral Group
In a floral group, the light will fall on a particular bloom, which in turn will create shadows on the others.

◀ Rosebud
A rosebud can be blocked in with strong color and darker tones added for shadows, creating a firm shape. A full-blown rose is more flimsy in outline.

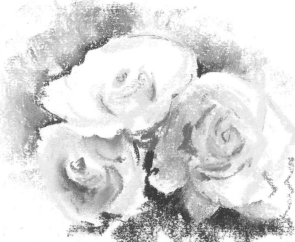

Background influence

You can save time by selecting the background paper color to complement the painting, making use of it in areas where the pastel is applied thinly. With a dark background, the subject can be painted to appear as if it is emerging from the shadows, which creates a dramatic effect in a short space of time. Similarly, a light paper can play a part in the composition for stronger colored flowers, especially when you are diluting pastels with water to create watercolor-style effects.

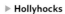 **Hollyhocks**
12 × 18 in. (30 × 45 cm.)
The strong dark red paper gave me an excellent base for quickly blocking in the bright reds of the flowers and green areas for foliage. Gaps between the pastel applications show the paper color, which enhances the subject.

◄ **Squared forms**
A box shape provides
the basis for most
types of building,
both domestic and
commercial.

Observing shapes

**Your paintings will always benefit
from any spare minutes you can
spend at home observing ordinary
everyday objects and considering
their basic shapes. Whether you
are planning a composition indoors
or outdoors, this will help you to
draw with speed and economy.**

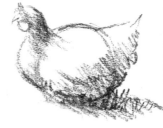

◄ **Circles**
A circle provides a
starting point for
many animals. In
larger animals, there
may be several.

Finding geometric shapes

Most beginners dread tackling buildings,
but seeing them as basic building blocks
of squares or rectangles will make it
easier to learn to draw them. At home,
sketch some box shapes out of your head
and turn them into building shapes, then
look at some photographs of buildings
and try to simplify them into boxes.

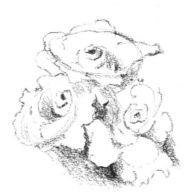

◄ **Ovals**
Many subjects in
nature, such as
flowers, and in the
home, too, are based
on ovals.

 Similarly, you can turn circles into
many subjects by embellishing the basic
shape. Most flowers and many animals,
too, can be started by drawing a series of
circles or ovals.

Creating a composition

Take some everyday objects you see regularly and work out their basic shapes and how they interact when placed next to each other. Move the objects about to create different compositions, not only in portrait and landscape formats but also squares and panoramas—don't limit yourself to just the shape of the paper in front of you.

Use your imagination to create different compositions, making quick thumbnail sketches of those that look promising. Those sketches, even the ones you discard, will represent minutes well spent because you won't waste time drawing and painting a composition that is ultimately unsuccessful.

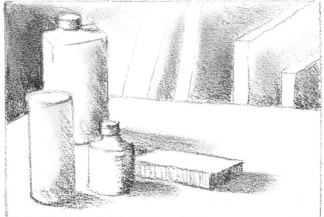

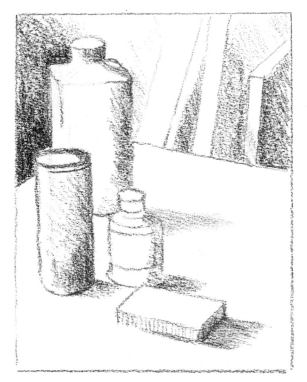

◀ **Choosing objects**
Everyday objects can provide an exercise in experimenting with composition. The shapes between them are just as important because they help tie everything together and balance the composition.

▲ **Trying different placings**
Before committing yourself to a painting, move the objects around and change the angle to create a different composition.

Portraits

To make a start with portraits, it is helpful to observe people from a distance and practice doing quick sketches. These need not be full facial studies because side or rear views can equally capture the look of a person. With the same strategy you have used for other subjects, catching the large shapes of head and shoulders first before starting on facial features will be a faster approach, and it can also help you to achieve movement, especially if people are unaware of being watched.

Capturing the pose

Portraits can be recognizable even without features if the proportions of head to shoulders and a typical pose are captured and if the color is simplified and bold. Someone who habitually sits in a slouched position, for example, will be easily distinguished from someone who sits upright, and standing figures, in particular, allow the artist to be expressive and exaggerate mannerisms that would otherwise not be noticed.

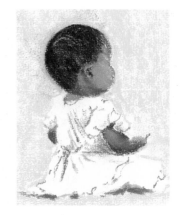

▲ **Indian Baby**
Outlining the shape of the baby in a white dress and blocking in the background colors made the shape stand out as light against dark, giving extra impact.

▶ **Portrait of John**
Catching people unawares is a great way to collect casual poses for adding into paintings later. By the time the person realizes you are sketching them, the main work is done.

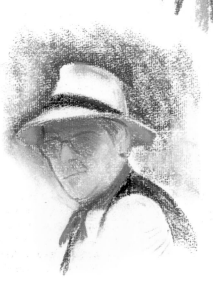

▲ **Indian Girl**
The pose is important to create the mood and character of the person. Our tour guide looked bored as she sat waiting for the group to arrive!

Simplifying features

If the features on portraits are too detailed, the effect can be heavy, which can distort the likeness and sometimes add years to a person's face, particularly in the case of children's portraits. By softly simplifying and understating the details, an impression of the person is formed that leaves something to the imagination. This avoids the work being too photographic and saves valuable time, making a 30-minute pastel even easier to achieve.

▶ Girl in Hat
9 × 12 in. (23 × 30 cm.)
The dark blue paper shows off the strong light shape of the hat for impact and creates a cool balance against the warm pink and cream skin tones.

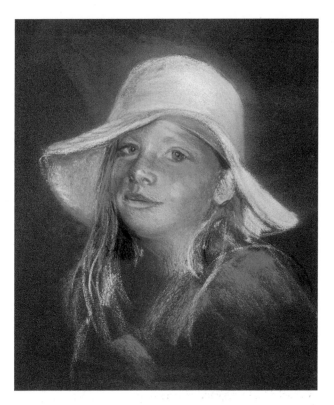

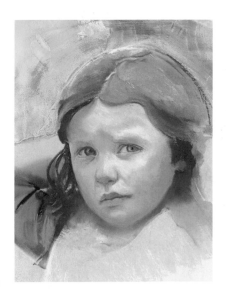

◀ Portrait of Cody
9 × 12 in. (23 × 30 cm.)
Using a light background allowed me to wet the first pastel applications to create a watercolor wash effect. Once they were dry, I built dry applications of pastel on top to create a soft blended effect for a child's skin.

Including props

Some people are particularly recognizable by the way they dress. Props, such as hats and glasses, make the likeness easier to achieve because they act as distinguishing features. They are also helpful for taking measurements when you are placing the position of the features.

Hats and glasses hide part of the face. Don't attempt to paint what you cannot see—always stick to the features that are clearly visible.

Working from photographs

There is a great temptation to take a long time over a painting when you are working from a photograph. Comfortably settled at home, you will find it all too easy to settle into copying mode, where the drawing is meticulously reproduced and color mixing becomes color matching. Take a tip from the American watercolorist Ed Whitney, who once said, "I don't want the truth, I want beautiful lies." By selecting the important elements of a photograph and rejecting unimportant details, it is possible to create a fresh, personal rendition of the subject.

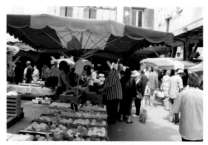

▲ **Market scene**
For a complicated scene, take a lot of snaps to get the general shapes. You can then move these around in your composition as you want. Incidental figures will come in useful for putting into many paintings.

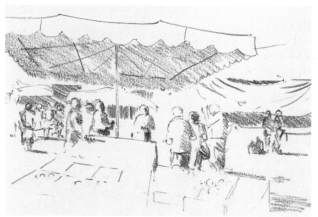

◀ **Tonal sketch**
When you are using a photograph, it is helpful to spend a few minutes first on a quick tonal thumbnail sketch, working in pencil or hard pastel, and sketching main shapes to work out the composition.

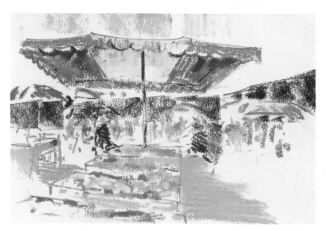

◀ **Color sketch**
Another way of quickly testing out a composition is to do a color sketch without drawing, blocking in large areas of lights and darks without any details. Moving shapes around experimentally is always worth a try and gets you away from copying what is there already.

Changing the format

A great way of exercising your imagination with a photograph is to take it in landscape format then see if it can successfully be changed to a portrait, square, or panoramic format. Playing around with the composition instead of relying on the original format often produces great paintings.

When I am trying out different formats, I draw "floating boxes" of varying shapes within the page of a sketchbook. This allows me to add or subtract to alter the outer shape, experiment with the format, and recompose the picture. When the problems of composition have been worked out and improved, I can then start on the final painting.

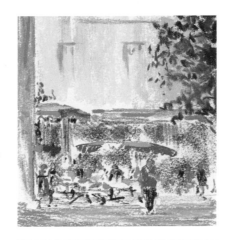

◄ **Square format**
A square format encloses the composition, which creates more focus on the people in the market and gives less importance on the buildings around.

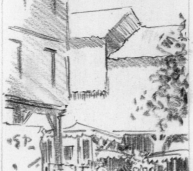

◄ **Portrait format**
Another quick tonal sketch extends the buildings to include the sky and rooftops and gives a completely different mood to the scene.

▲ **Market scene**
This photograph was taken as a landscape format, but, by trying out "floating boxes" within the page of a sketchbook, I extended the sides to alter the composition and try more options.

◀ **Highland village**
Bland subjects in photographs that you don't have time to paint on location can be made more exciting by switching on the sunshine on an otherwise dull day and creating new compositions in pastel colors that inspire you.

Capturing atmosphere

Adding atmosphere to an otherwise dull photograph can improve the subject and make it more imaginative. This is particularly helpful where there is a lack of detail available in a poor-quality photograph, or where the weather conditions have not been ideal for capturing the image. The photograph becomes a simple record of events and allows the artist more scope to be expressive.

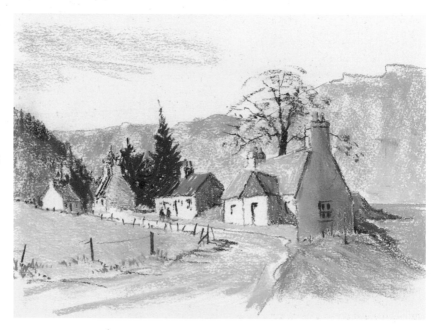

▶ **Highland Village**
9½ × 14 in. (24 × 35 cm.)
The two photographs of this street were both dull because it was about to rain, but, by using elements of each, recomposing them into a new landscape format, and adding sunshine to give more depth, an interesting picture was created.

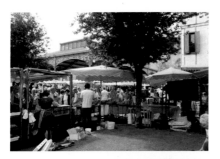

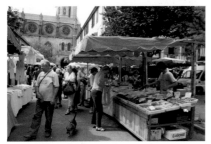

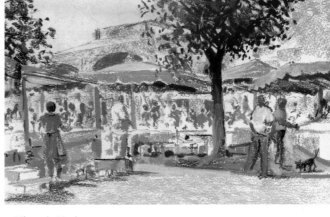

◀ **Market stalls 1**
I liked the left side of the composition but felt that the right was nondescript and needed the introduction of another angle to bring the eye into the main market scene.

◀ **Market stalls 2**
The stall in this photograph offered the ideal angle to add onto the composition and make a slightly panoramic format, which had the possibility of an interesting picture.

▲ **Mirepoix Market**
7½ × 12½ in. (19 × 32 cm.)
The light streams into the market square from the left and now gives a more enclosed feeling to the scene, with figures from both photographs used to add interest. The complicated subject at the back of the stalls is merely suggested to give a feeling of crowds.

Multiple photographs

Using several different photographs for reference and taking elements from each can create new and exciting compositions. You will need to make sure that you keep the light coming in from a consistent source, and be particularly careful with proportion when you are placing subjects next to each other. Selecting the best points of each photograph also helps you to avoid the habit of copying what's actually there and be more creative.

QUICK OVERVIEW

☐ Keep still life groups simple and uncluttered when you are working within the 30-minute time frame.

☐ Look at every option possible to portray your subject—don't just accept the first angle you arrive at.

☐ Capture simplified large main shapes first before adding any detail.

☐ Use photographs creatively.

Painting a still life

By limiting this exercise to simply pastel pencils and hard pastels, it is easy to paint a still life quickly at home without making too much mess. It will also exercise both your drawing and painting skills in the space of 30 minutes.

MATERIALS

Canson Sand pastel paper
Stabilo Carb
Othello pencils
Dark green
Dark gray
Ochre
White

Conté Carres crayons
Bright green
Bright red
Cadmium yellow
Orange
Pink
Warm gray

1 With your dark green pencil, sketch in the total outer shape of the flowers, hat, and pruners, ensuring that everything will fit onto the paper. No detail is needed because this simply sketches the plan and confirms the composition. Note the direction of the light source and add shading to establish tone.

2 Block in the colors using Conté crayons and pastel pencils, keeping the color scheme simple and limited. Block in the tonal values to create the pattern of light on each object and leave the neutral paper for highlights. Note how the light background needs to be darkened slightly to allow the pale-colored flowers to stand out.

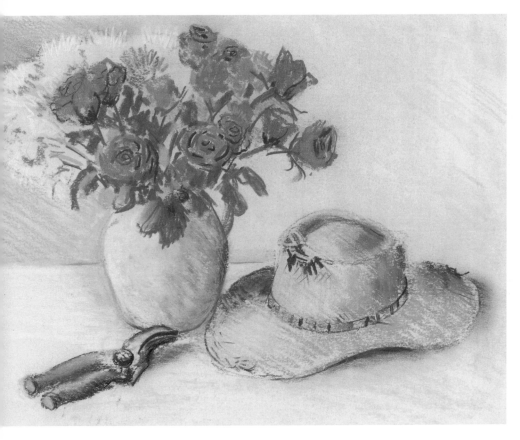

3 Build up the final colors to create more details and texture. Continue to emphasize the light and shade by putting stronger contrasts against areas that need more impact—for example, adding white to the pale flowers against their darker background. Finally, blend some textured areas, such as part of the hat, to emphasize their rough texture elsewhere.

◀ **Still Life with Flowers**
11 × 15 in. (28 × 38 cm.)

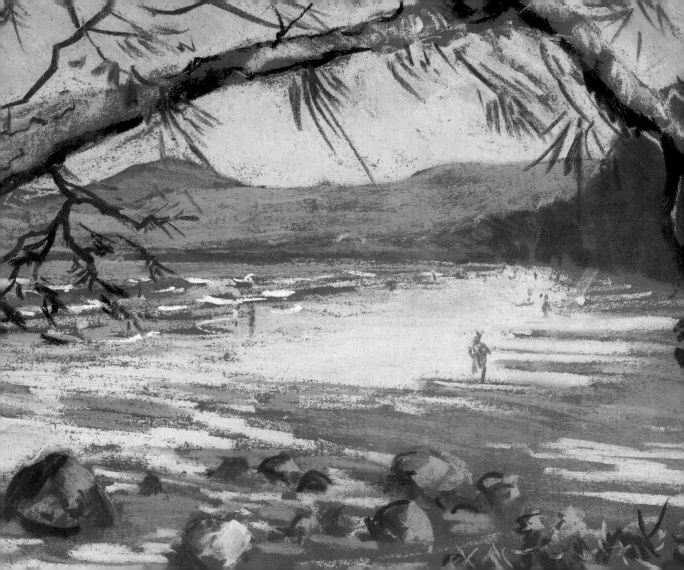

WORKING OUTDOORS

Working outdoors is exciting, but it can be frustrating without a plan of action. That's why the 30-minute pastel is perfect for this situation. With some organizing, it is possible to set up simply, assess the subject quickly, take a photograph for reference later, then go for it, keeping in mind the impact that is needed to convey to the viewer what attracted your attention in the first place.

I tell my students, "Paint outdoors as if the bus is leaving without you in five minutes!" It's amazing what you can get down on paper in 10 minutes, or even 5, and that leaves extra time for bonus work, such as adding more detail in the landscape.

◀ **Cairns Beach, Australia**
9½ × 13 in. (24 × 33 cm.)
It was hot yet windy when this was done—not a good day for working in pastels! A 20-minute impression of the long beaches gave enough detail, backed up with photographs for a later painting.

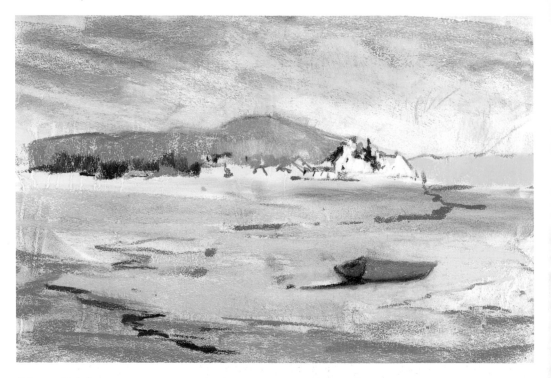

▶ **Plockton, Scotland**

13 × 19½ in. (33 × 50 cm.)

By wetting each layer of pastel and letting the washes run together and create a quick impression, I captured the bare essentials in 10 minutes to create the light of the evening sun.

Simplifying landscapes

The majority of landscapes can be divided into background, middle ground, and foreground; an open landscape may split into sky, water, and foreground. Putting in the large shapes is the first step in order to ensure that you are able to fit everything you want on your paper. Learn to see trees as a mass and rows of houses as one shape. The mass shapes also help to determine later where the quiet areas of the painting can be, as opposed to the busy parts, which will be screaming out for attention to details.

Capturing the grand scale

A basic understanding of perspective will help you to dramatize the angles and viewpoints of a scene and capture the grand scale. Many panoramic or busy scenes seem too complicated and leave the artist not knowing where to begin, but remember that you do not have to copy exactly what you can see. By concentrating on those big shapes and making the eye level exciting, it is possible to create the feeling of grandeur.

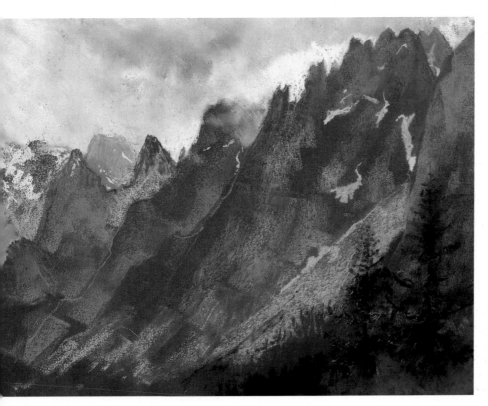

◀ **Austrian Alps**
12 × 18 in. (30 × 45 cm.)
From the top of the ski lifts, the drama of looking down across the mountains is accentuated with a high eye level, creating plenty of room for showing the depths below and exaggerating the angles.

▌QUICK TIP

Painting contre-jour (against the light) helps you to see simplified outlines of shapes because the detail is bleached out by the light. This technique makes painting easier and it looks more dramatic.

Painting trees

When you are tackling a single tree, imagine it is placed against the light and see just the profile. Make sure the span of its canopy fits into the space on the paper and measure how wide the tree is compared to its height. This helps to define whether the tree is tall and thin or short and wide. Keeping the background simple behind a feature tree will focus attention on the textural qualities of the tree and give it more impact.

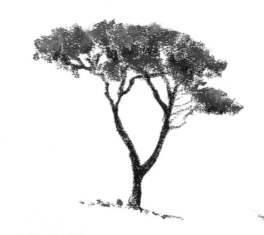

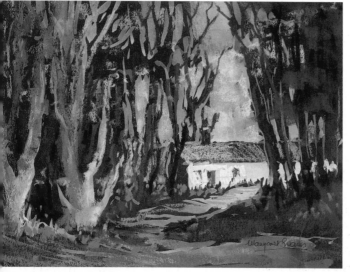

◄ **Woodland Path**
8 × 11 in. (20 × 28 cm.)
Dark paper suggests the mystery of the woodland and blocks of thick pastel enhanced with some white gouache create a body of color where the white house is. I added thicker highlights of pastel to the trees and diluted mid- to darker tones with water to sink into the paper color and create shadows.

▲ **Tree colors**
Never start by painting a brown trunk and green foliage because it makes the tree look like a child's painting. Generally, trees are silhouetted against light sky, so a dark greenish brown will capture the outer shape. Lighter greens and browns can be added later for detail if necessary.

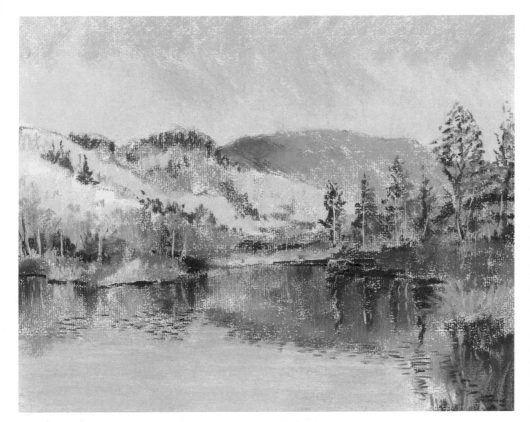

◀ Woodland Trees
10¼ × 12¼ in.
(26 × 31 cm.)
The bulk of trees in the distance are blended to create a softer impression without detail. The rough paper and unblended pastel in the foreground and middle distance add extra texture for layers of trees, with one or two detailed slightly more than the others.

Grouping trees

In a woodland scene, the main bulk of trees can be divided into background, middle ground, and foreground trees. Portraying one or two main character trees in more detail will create focal points, but don't emphasize too many—this will make the painting unfocused. Use similar colors throughout to ensure unity and enhance the tonal differences.

Reflections in water

Observing how a single item, such as a tree or building, reflects in water will help you to understand the effect that water has on a mirror image. Ideally, find a quiet pond of calm water and look at the still reflection—squinting through half-closed eyes helps, because the mid-tones disappear and the subject is simplified into dark and light shapes.

Note how the still reflection lengthens the shape, and how it may be darker in tone than the shape itself. Now throw a stone into the water and observe how the ripples that are created distort the mirror shape and extend it into a wider, deeper shape, with wonderful jagged edges.

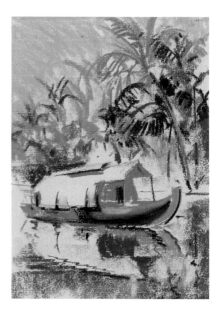

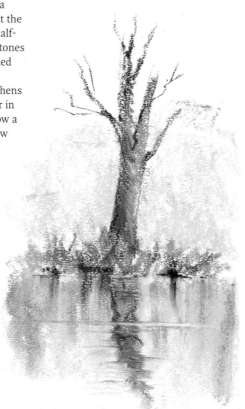

▶ **Single Tree Reflections**
The colors of the single tree are repeated in the water area and blended with a downward stroke to create the impression of the depth of the water. Dragging a plastic eraser across reflections gives the appearance of surface movement.

▲ **Rice Boat Reflections**
6½ × 8½ in. (16 × 22 cm.)
I built up the reflections at the same time as I painted each shape and color on land, allowing the reflections to represent the water in its entirety.

Multiple reflections

Multiple shapes, such as buildings, create a pattern that lends itself almost to abstraction. To show distorted shapes in water, let the vertical reflections merge horizontally, making a fascinating pattern of colors. When you are painting reflections, such as this, it is easiest and quickest to block in the mirror image with vertical strokes to repeat the shapes above the water and give the appearance of its depth, then use a damp brush with horizontal strokes to create a zigzag pattern, letting the colors to knit together. Finally, adding some light reflections on the surface of the water will provide additional depth.

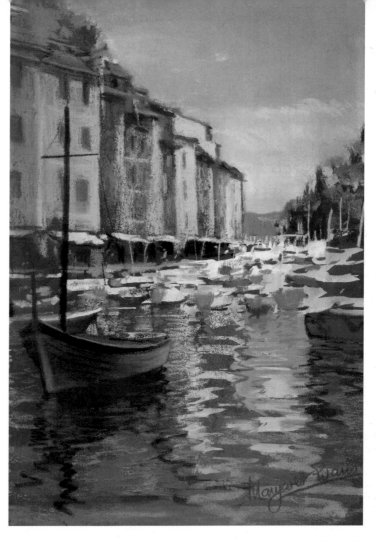

▶ **Portofino**
8 × 12 in. (20 × 30 cm.)
The emphasis on the stunning deep blue sea and sky helps to identify this scene instantly as a Mediterranean one. The blues create a strong cool balance against the warm terra-cotta color of the buildings.

Skies

Even in the case of a clear blue sky, it is important to create a sense of perspective and depth by gradating the tone of blue. The sky at the top of the picture is closer, and is, therefore, usually stronger in color; toward the horizon it becomes paler. Remembering this will help you to achieve quick and convincing results.

Painting clouds

All objects need highlights and shadows in order to appear three-dimensional, and exactly the same principle holds true when you are painting clouds. By using an off-white or creamy base color to block in the cloud formations, you can then add the darker shadows beneath with a gray or purplish blue and the highlights with white.

Dramatic sky effects

Although these basic formulas are very helpful to use for quick sky recipes, you must never forget to draw upon your own observation. It is not the case that clouds are invariably shadowed from beneath, nor is the lower part of the sky always lighter than the top. You will always see skies and cloud formations that break the rules, and this can add to the drama of a sky as it seizes the viewer's attention.

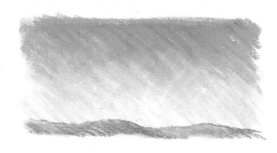

◀ **Clear skies**
A general formula for a clear blue sky is to make the blue stronger at the top of the painting, where the sky is nearer the viewer, and paler toward the horizon.

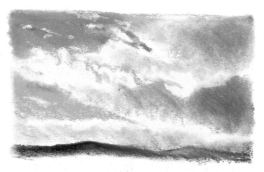

◀ **Clouds**
Negative painting around the cloud shapes with blue sky color will position the clouds and give the basic shapes before darker colors are added to give the clouds more form and tone.

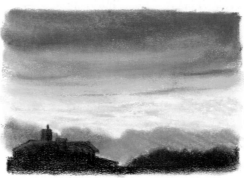

◀ **Dramatic skies**
Observation is the best way to learn how to capture dramatic skies, especially sunsets. This predominantly orange sky has palest turquoise and cream in the distance and dark clouds on the horizon.

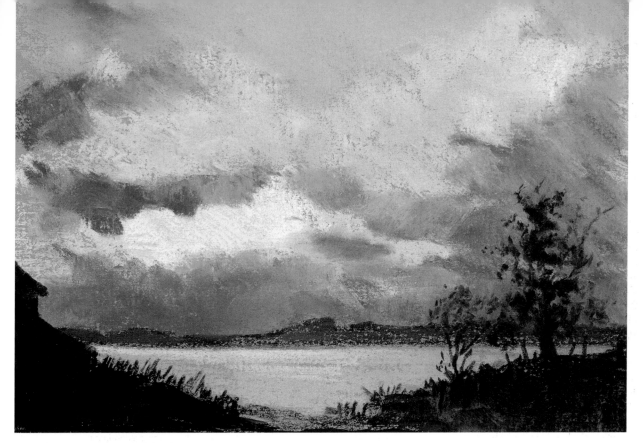

▲ Evening Clouds
7 × 10¼ in. (18 × 26 cm.)
Because there are
dark, dramatic clouds
in the distance, the
horizon is darker
than the sky at the
top of the picture.
As here, evening
clouds are often in
the complementary
color of purple
against the orange
light from the sun.

▶ Looking up

If you are looking up at the subject, your eye level is low. There is not much foreground to fit in, because the majority of action will be above the eye level.

▶ On the level

A central eye level cuts the picture in half. Your painting will be improved by adjusting your eye level and putting more above or below the center.

▶ Looking down

Looking down on a subject means that your eye level should be placed high on the paper, leaving plenty of room for the details below.

Buildings

With regard to perspective, when you are working quickly the most important point is to assess angles and, once you have recognized them, to exaggerate and dramatize them.

Work out your eye level first and draw a line across the paper to help remind you where it is. You can then see immediately whether the main content in the picture is above or below this line, and whether your eye level is low or high, respectively. It is not good practice to place the eye level in the center, so if you realize there is as much above the line as below, consider where there is more to emphasize then raise or drop that line slightly to avoid cutting the picture in half.

Vanishing points

Parallel lines leading toward the horizon converge at what is called the vanishing point, which will always be at eye level. In a 30-minute painting there is little time to spend on detailed perspective, but be aware of whether roof lines, for example, are going up or down to meet your eye level. Assessing roughly at which point a roof line would meet that eye level if it were extended will give you a vanishing point where all other parallel lines on the same house would meet.

Different moods

You can bring enormous variation to the same subject by exaggerating and altering angles and using different papers to change colors, backgrounds, and textures. A very rough paper can create plenty of texture for old, crumbling buildings, and you can dramatize the mood and atmosphere by using a strong background paper color.

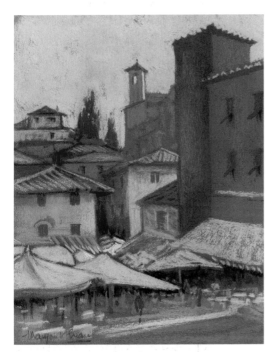

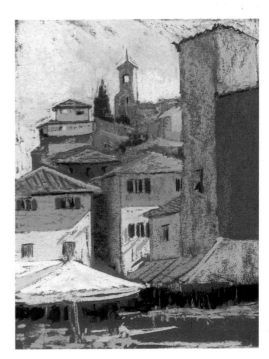

◄ **Montecatini 1**
10 × 12½ in. (25 × 32 cm.)
The evening glow of the Tuscan sun is enhanced with the warm tone of the red paper, which I left uncovered in places in order to add to the strength of the reds. I used a neutral blue gray to add coolness to the busy areas where people are milling around.

▶ **Montecatini 2**
10 × 12½ in. (25 × 32 cm.)
A cooler version of the same scene shows the different mood created by using a darker red paper, which still contributes warmth to the scene but is played against cooler stone colors on the buildings.

Figures

Adding human life to a scene will not only make it come alive but will add to the sense of scale, help to draw attention to a focal point, and make the whole scene more interesting.

Practicing quick figures

Working on a general rule that the head is one-eighth of the body, a stick can give a basic size for positioning a figure. Find the top eighth by halving it, then halving the top section twice more to give the proportion of the head.

From this point, the shoulders are wide, then the body tapers down to below the halfway point. Beneath this you can position the legs to stand or walk. Practice plenty of varying positions and shapes to vary the characters.

Grouping figures

To show figure groups, block in blobs of color, then add heads and legs. This creates plenty of animation without the need for any details, which would take up valuable time.

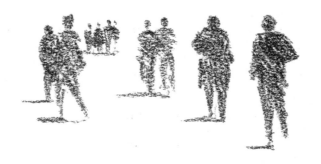

◀ **Quick figures**
Most figures are seen as dark against light, so using a dark blue or brown simply sketch in a head, widen for the shoulders, then taper down to the legs, always adding a shadow for volume.

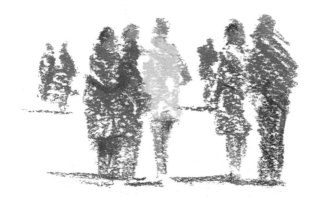

◀ **Groups**
Having fun with bright splashes of color, adding suggestions of heads and legs, will turn paint smudges into impressions of animated figures.

▼ Mexican Picnic

8¼ × 12 in. (21 × 30 cm.)
This sketch of a family having a picnic in the shade shows counterchanged figures against varying tones. The dark paper allows details, such as the legs and tree branches, to blend into the shadows, and the sunny highlights give maximum contrast.

Counterchange

Positioning figures in the correct place is important for catching the eye or filling empty spaces, and tonal values play a large part in emphasizing them. Place a light figure against a dark background and vice versa to create more interest; this juxtaposition of dark and light is known as counterchange. Give less important figures less impact against their background.

◄ Counterchange
Putting some figures as light shapes against dark backgrounds, such as inside doorways, and balancing this with some dark figures against light adds tonal depth to paintings.

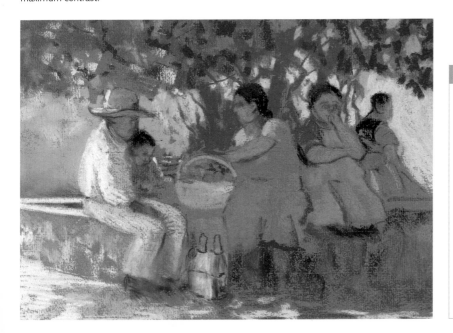

QUICK OVERVIEW

☐ Divide landscapes into background, middle ground, and foreground and look for mass shapes.

☐ Accentuate angles for drama.

☐ In a woodland scene, pick out one or two trees to create focal points.

☐ A clear blue sky is stronger in color overhead than on the horizon; dark clouds may reverse this.

☐ Choose an eye line that is not exactly central in your picture.

☐ Add human figures to give scale and animation.

Painting a landscape

When you are working on location the light will change constantly, so it is important to get the large areas blocked in quickly to capture the moods and tonal contrasts before considering any details.

MATERIALS

Ingres off-white pastel paper	Burnt sienna
Light gray Conté Carres crayon	Cobalt blue
	Dark brown
Soft pastels	Indigo
Blue gray	Pale blue
Bright green	Pale burnt sienna
Bright red	Reddish brown

1 Begin by drawing the outline with the light gray pastel stick. Next block in the cool shadow colors with enough strength to ensure that they will still show through after you have subsequently blocked in the main colors.

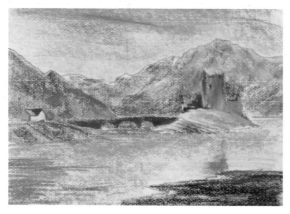

2 As you build up the main colors, the uniform texture of the paper will become apparent. Resist the temptation to start rubbing and smoothing this texture in places because it can be dealt with later—the changing colors and tones are first priority. Lay in basic colors first, exaggerating them slightly. Keep blended colors fresh and don't try to match nature.

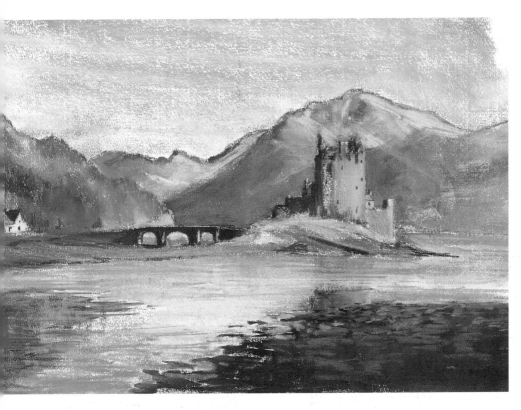

3 Blend a few areas where the paper texture is still dominant and a smoother finish is needed. However, leave the combination of texture and color mixes alone in the hillside to create the tapestry of colous in the landscape. Strengthen the tones, making darks darker and lights lighter, then add final touches of a few linear marks for detail to the house, bridge, and castle.

◄ **Eilean Donan**
12 × 18 in. (30 × 40 cm.)

FURTHER INFORMATION

Here are some organizations or resources that you might find useful to help you to develop your skills.

Art Magazines

American Artist
770 Broadway
New York, NY 10003
tel: (646) 654-5506

Artists & Illustrators
26-30 Old Church Street
London SW3 5BY England
www.aimag.co.uk

The Artist's Magazine
4700 E. Galbraith Road
Cincinnati, OH 45236
tel: (513) 531-2690

www.artistmagazine.com
International Artist
P.O. Box 4316
Braintree, Essex CM7 4QZ England
www.artinthemaking.com

Art Materials

Blick Art Materials
tel: (800) 723-2787
www.dickblick.com

Cheap Joe's Art Stuff
tel: (800) 227-2788
www.cheapjoes.com

Daler-Rowney, USA
2 Corporate Drive
Cranbury, NJ 08512
tel: (609) 655-5252
www.daler-rowney.com

Daniel Smith
tel: (800) 426-7923
www.danielsmith.com

Jerry's Artarama
tel: (800) 827-8427
www.jerrysartarama.com

Pearl Art and Craft Supply
tel: (800) 451-7327
www.pearlpaint.com

Savoir-Faire
40 Leveroni Court
Novato, CA 94949
tel: (415) 884-8090
www.savoirfaire.com

Utrecht
6 Corporate Drive
Cranbury, NJ 08512
tel: (800) 223-9132
www.utrecht.com

Art Societies and Organizations

International Association of Pastel Societies (IAPS)
P.O. Box 2057
Falls Church, VA 22042
Fax: (703) 536-0308
www:pastelinternational.com/

Pastel Artists of Canada (PAC)
P.O. Box 351
Flesherton, ON
Canada NOC 1E)
tel: (519) 924-2202
www.pastelartists.com

Pastel Society of America (PSA)
15 Gramercy Park S.
New York, NY 10003
(212) 553-6931
www.pastelsocietyofamerica.org/

Internet Resources
Art Museum Network
The official website of the world's leading
art museums
www.amn.org

Great American Artworks
Web site run by a manufacturer of soft
pastels, providing links to artists, galleries,
and products.
www.greatpastels.com

Margaret Evans
The author's website, with details of her
workshops, holidays, books, DVDs, and a
gallery of her work.
www.shinafoot.co.uk

Open College of the Arts
An open-access college, offering home-
study courses to students worldwide.
www.oca-uk.com

Painters Online
Practical art site run by The Artist's
Publishing Company and packed with
information and inspiration for all artists.
www.painters-online.co.uk

WWW Virtual Library
Extensive information on galleries
worldwide
www.comlab.ox.ac.uk/archive/other/
museums/galleries.html

FURTHER READING
Why not have a look at other art
instruction titles from Collins?

Balkwill, Ray, *Learn to Paint Coastal
 Landscapes*
Bellamy, David, *Learn to Paint Watercolor
 Landscapes*
Blockley, Ann, *Watercolor Textures*
Crawshaw, Alwyn, *Alwyn Crawshaw's
 Ultimate Painting Course
 30-minute Sketching*
French, Soraya, *30-minute Acrylics*
Jennings, Simon, *Collins Artist's Color Manual
 Collins Complete Artist's Manul*

Keal, Jenny, *Learn to Paint Landscapes in
 Pastel*
King, Ian, *Gem Watercolor Tips*
Peart, Fiona, *30-minute Watercolors*
Simmonds, Jackie, *Gem Sketching*
Simmonds, Jackie, Wendy Jelbert and
 Marie Blake, *Need to Know? Drawing
 & Sketching*
Soan, Hazel, *Gem 10-minute Watercolors
 Learn to Paint Light and Shade in
 Watercolor
 Secrets of Watercolor Success*
Trevena, Shirley, *Vibrant Watercolors*
Waugh, Trevor, *Winning with Watercolor*
Whitton, Judi, *Loosen up your Watercolors*

For further information about Collins
books visit our website:
www.collins.co.uk

INDEX